PAINTING
sunlight
& shadow
WITH PASTELS

essential techniques
for brilliant effects

Maggie Price

NORTH LIGHT BOOKS
CINCINNATI, OHIO
www.artistsnetwork.com

Contents

The Basic Principles of Light and Color

Discover the most important principles of depicting natural light and shadows through color in your paintings.

Observing the Color of Light

Explore three of the most common environmental factors to take into consideration as you attempt to portray the color of light in your compositions: air quality, altitude and weather.

Creating Realistic Shadows

Uncover the many ways that shadows help describe form while enhancing the appearance of light, making your paintings more believable.

Painting Lifelike Reflections

Learn about the different elements that influence the appearance of water's reflective surface, from the angle of light to the slant of the surrounding land mass.

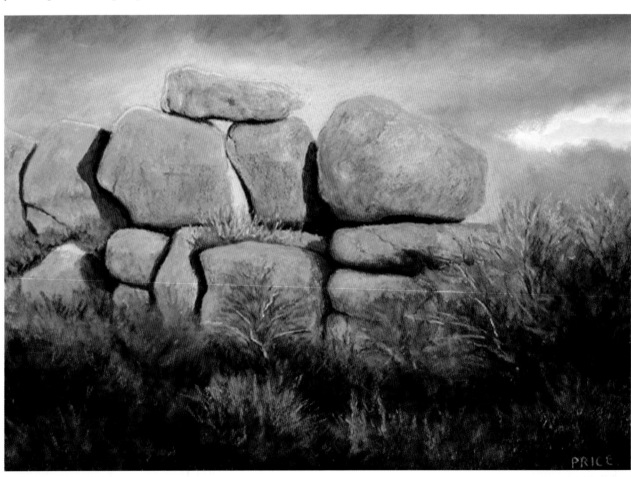

The Boulders - Maggie Price
Pastel on Richeson premium pastel surface - 16" × 20" (41cm × 51cm)

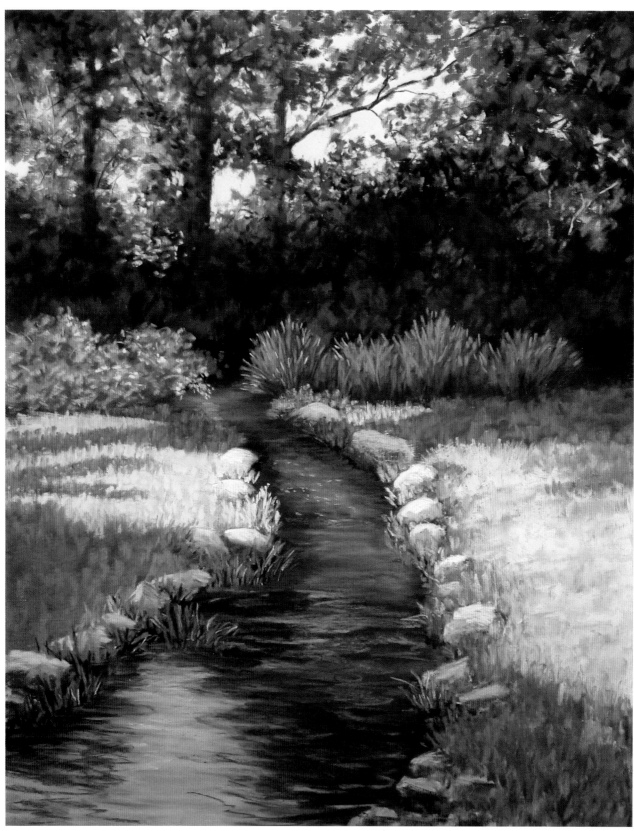

Lazy Afternoon - Maggie Price
Pastel on Pastelmat - 20" × 16" (51cm × 41cm)

Introduction

Whether you paint outdoors in natural light or indoors from photographic references, understanding and accurately representing the effects of sunlight and shadow are crucial to making your paintings lifelike and believable.

Sunlight and shadow are the inseparable elements of describing form. A shape portrayed as totally in sunlight can appear flat and one-dimensional; a shape totally in shadow may nearly vanish. Think back to the basic exercise of drawing a cylinder and its components: the side facing the light source, the dark shadowed side opposite the light source, and the halftone area between where light and dark merge to create the dimension and shape of the cylinder.

These basic elements of light, dark and halftone are the first building blocks of describing form, but they are just the beginning. Exploring the nuances of sunlight and shadow can take as much time as the artist is willing to give.

While many of the concepts covered in this book can be applied to any medium, the illustrations, demonstrations and techniques shown are all in soft pastel. In my early years of painting, I worked in oils and journeyed through the mediums of acrylic, gouache and watercolor before I arrived at pastel. The luminosity and brilliance of this medium, together with its forgiving nature and ease of application, enchanted me from the beginning. If you're new to the medium, you'll find the step-by-step demonstrations especially helpful; if you're an experienced pastelist, I hope the demonstrations and concepts will open new doors of understanding.

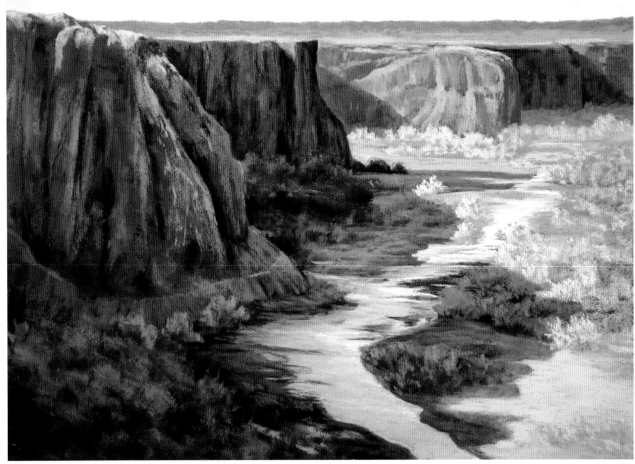

Canyon Shadows - Maggie Price
Pastel on Richeson premium pastel surface - 18" × 24" (46cm × 61cm)

Tool Checklist

BRUSHES

¼-inch (6mm), ½-inch (12mm) and 1-inch (25mm) synthetic brushes; ½-inch (12mm) fine mop brush; nos. 4, 6 and 12 watercolor brushes; no. 10 Filbert

PASTELS

Soft *(a minimum of 5–10 values of each of the following)*: beige, black, blue, blue-green, blue-violet, blue-gray, cool brown, gray-green, green, orange, red, red-orange, red-violet, reddish gray, violet, violet-gray, warm brown, white, yellow, yellow-orange, yellow-green

Harder *(3–5 values each of the following)*: black, blue, brown

Pastel pencils: black, brown, light yellow, white

SURFACES

Ampersand Pastelbord, Canson Mi-Teintes, Pastelmat, Richeson premium pastel surface, UArt sanded pastel paper, Wallis sanded pastel paper

WATERCOLORS

Alizarin Crimson, Burnt Sienna, Burnt Umber, Cadmium Yellow (light and medium), Cadmium Yellow-Orange, Cadmium Red-Orange, Carbazole Violet, Cobalt Blue, Dioxazine Violet, Payne's Gray, Raw Umber, Sap Green, Titanium White, Ultramarine Blue, Winsor Green, Yellow Ochre

OTHER

Barrier cream (such as Gloves in a Bottle) or tight-fitting gloves, drawing pencils, drawing paper, fixative, foam pipe insulation, kneaded eraser, paper towels, pencil sharpener, ruler, tape, Turpenoid (blue label), rubbing alcohol or other mineral spirits

So What, Exactly, Is a Soft Pastel?

The term "soft pastel" encompasses a range of pastel sticks from harder to softer. When people refer to "hard pastels," they are actually referring to the harder form of the medium called "soft pastel." In fact, many pastelists feel the medium should be called dry pastel to cover both the harder and softer versions, and to differentiate them from oil pastels. Soft pastels come in a variety of textures, from long, skinny, hard sticks to soft, buttery, rounded or squared chunks.

All pastels in the category of soft pastel are pure pigment (the same pigment used in oils and watercolors) mixed with just enough binder to hold the sticks together. They are applied dry by stroking the stick, held on its side or point down, upon a surface. Most often those surfaces are made especially for pastels and include textured paper and sanded surfaces designed to grab the pigment.

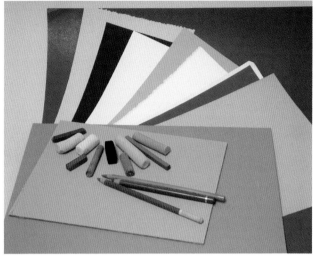

SOFT PASTELS AND SURFACES FOR PASTEL PAINTING
Surfaces vary in the amount of "tooth," or surface texture, which holds the pastel pigment. Pastel sticks vary in shape and degree of softness. With a good toothy surface, you can use either hard or soft pastels, freeing you to make your choices based on color, value and temperature.

LAYING IN A BROAD STROKE
For a good portion of your painting, you'll lay in strokes of color with the pastel held on its side. This is the equivalent of the "big brush" in oil or other wet mediums. Beginning with large shapes of color will keep you from getting bogged down in details too early in the development of the painting. Holding the pastel on its side and stroking lightly is also the best way to layer color.

GETTING TO THE POINT
The pastel held more like a pencil is often used for smaller shapes and detail work. Harder pastels, whether square or round, may work best for small shapes. Some of the long, hard pastel sticks can even be sharpened to a point with a knife or handheld pencil sharpener.

Working Your Way Forward

It's a good idea to work from background to foreground with pastels. This ensures that each mark you make lays down properly, with foreground marks over background marks.

How Should I Arrange My Pastels?

Pastel artists are faced with a delightful but dizzying array of pastel sticks. Every time you prepare to make a mark on your surface, you must first select a pastel stick by considering its value, temperature and hue (color). How you arrange your pastels can make this selection easier.

Selecting a Box

Rather than keeping each set of pastels in the box it came in—which can result in a confusing jumble of sets—it's a good idea to put all the pastels you want to use in one well-arranged box. This box can serve as your studio set as well as your traveling set if it's small enough. If you prefer a large box for the studio, you may want a second smaller box for painting outdoors.

Many boxes are commercially available, but some artists prefer to build their own or make their own modifications. Whichever you choose, the ideal box will have six divisions into which you can sort your pastels by temperature and value.

Determining Temperature

As you begin to arrange your pastels, you'll find that obvious warm colors, such as red and yellow, are easy to identify, and that obvious cool colors, such as blue, are easy to see. The ambiguous colors are a little more difficult. For instance, looking at purple, you may have to ask, "Is it more blue than red? Or more red than blue?" Green is the most difficult color to define in terms of temperature. The easy solution is to place your greens in the middle of the top-to-bottom temperature division.

Perceiving Value

Organizing your pastels is an exercise in perceiving value. Your eye can see far more than six value distinctions, so as you place each pastel, ask yourself, "Does it fit better in this value section or in this one?" Over time, you may move a pastel from one place to another as your perception of value improves. And as your perception of value is sharpened from the practice of organizing pastels, you'll find your perception improving as you look at your subject, your photograph or the painting on your easel.

| Lightest light | Middle light | Darkest light | Lightest dark | Middle dark | Darkest dark |

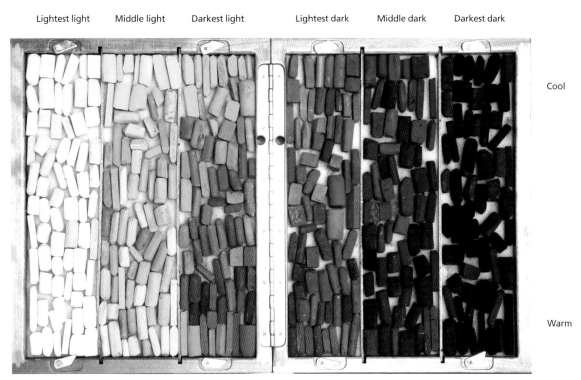

Cool

Warm

ORGANIZING YOUR PASTEL BOX
The six box divisions are organized by value from left to right and divided by temperature from top to bottom.

Underpainting

Beginning your pastel painting with an underpainting can help improve the final result and set the tone for the entire painting. It allows you to quickly cover the blank surface with a simple arrangement of shapes in a limited number of colors or values. Because the preliminary underpainting layer is lightly applied and then lightly washed with a liquid medium, it remains thin and does not fill the tooth of the paper surface.

A good underpainting's simple arrangement of color and value provides a road map for the journey to a finished work.

There are various methods of underpaintings. In this illustration, five values of one hue are used to create harmony in the painting. You could use as few as three values, but you may find it beneficial to select up to five. Be sure to keep the pastels within the same temperature range as well as hue—if you're using purple, as shown here, don't add in a warm magenta, or the resulting underpainting will be less clear.

Watch Maggie show you how to work from a value road map at http://SunlightAndShadowWithPastels.artistsnetwork.com.

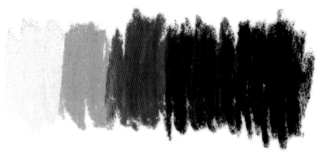

SELECTING THE COLORS FOR YOUR UNDERPAINTING
I chose five values of purple ranging from a very pale lavender to a deep violet. The colors were selected with consideration for the color of the light.

Keeping Your Hands Clean

If you cringe at the thought of pastel-stained hands, one solution is to apply Gloves in a Bottle or another barrier cream to your hands—or, if you're very tidy, just to the thumb and the two fingers that hold the pastels. Doing so creates "finger gloves" that will protect your hands without getting in the way of your painting. When you're done and wash your hands, the pastel will wash off quickly and easily.

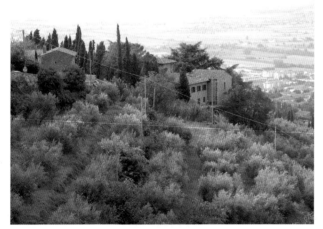

1 Examine the Reference Photo
Before you begin, study the reference photo to determine the most important elements; these are the ones that will be blocked in.

2 Sketch the Composition
I used a hard pastel to sketch the most important elements of the composition. If your subject is complex (like this one), draw a grid system for guidance. Don't worry about details though because your drawing will be covered by the underpainting.

3 Lay in the Underpainting

Using my five values, I blocked in the most important shapes. I skimmed very light layers of each color, holding the pastels on their sides as much as possible. I was careful not to scrub the colors into the surface or to completely cover the white of the paper since other methods are used to spread the color.

If you use too much pastel during this stage, you risk filling the tooth, so keep a light touch. Place the darkest darks first, followed by the middle values, then the lighter values. Squint as you work, and step back occasionally to see the big shapes of different values.

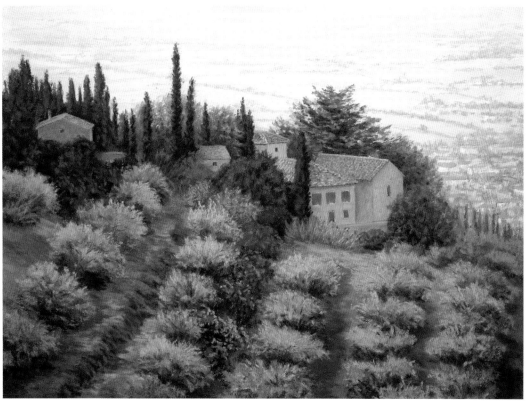

Fog in the Val di Chiana - Maggie Price
Pastel on Richeson premium pastel surface - 18" × 24" (46cm × 61cm)

4 The Finished Product

The division of values between the valley wrapped in a thin layer of morning fog and the closer buildings and olive grove was critically important to this painting. By beginning with a value-based underpainting (rather than an underpainting incorporating a wide range of colors and temperature as well as value), the values were clearly established in the very first step.

Once you have an underpainting and begin to add subsequent layers, don't hesitate to make modifications. In this case, the dark greens of some of the deciduous trees mixed in with the olives became a darker value than indicated in the underpainting, but still not as dark as the tall, dark cypress trees. The most important value difference—that of the foreground silhouetted against the valley—remained the same throughout.

Applying Turpenoid

Washing your pastels with Turpenoid creates a layer of pastel that is "melted" into the surface and separate from subsequent layers of color. It allows you to create a road map or value study in the first stage that can be built upon or altered as needed, without overly filling the tooth of the paper. Here are some turping tips to keep this process simple:

- **Put Turpenoid in a small jar with a tight-fitting lid.** You can save it and reuse it again and again. Be careful not to stir the liquid or dip into the pigment layer.

- **Use an old or inexpensive synthetic bristle brush.** Rough sanded surfaces will damage a brush, so you don't want to use your best.

- **Make sure your surface is upright, not flat.** A flat surface allows pooling of the turp and pigment; an upright surface keeps you from using too much.

- **Hold a paper towel in one hand** and dip the brush into the turp with the other. If you're using previously used turp, don't dip the brush all the way to the bottom of the jar or you will disturb the pigment layer. Blot the brush lightly on the paper towel to remove any excess.

- **Begin with the lightest value.** This helps prevent the Turpenoid from getting too dirty too soon. Carefully paint each section, wiping your brush often on the paper towel. Wipe off excess pigment on the paper towel before you dip the brush into the turp each time.

- **Keep the areas of values clean and separate.** If you allow them to blend too much, you can obliterate your value road map.

- **Blotting the brush can help you avoid runs**, but if runs occur, don't worry. It will not interfere with the final result unless there are dozens of them!

- **Cover the entire surface.** If you've applied the pastel lightly, you'll be surprised to see how little is needed to cover each section. When you're done, let it dry completely before adding pastel; it will dry in about 20–30 minutes. If you're in a hurry, use a hair dryer.

Some artists prefer to use mineral spirits or rubbing alcohol instead of Turpenoid. Experiment to see what you prefer.

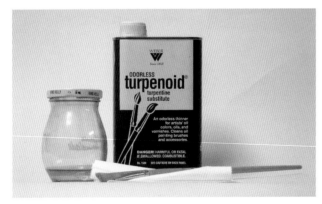

1 Gather the Underpainting Materials
After you've lightly laid in the pastel on your surface, collect your materials for the underpainting wash. You'll need a small jar with a tight-fitting lid, half-filled with Turpenoid or your preferred medium, an inexpensive synthetic brush and a good supply of paper towels.

If you choose to use Turpenoid, be sure to purchase the kind with the blue label; the green-label version does not dry completely but remains oily.

2 Lay in the Dry Pastel
Block in large, simple shapes of color, thinking about value and temperature as you select colors. Keep in mind that some of the underpainting may be visible in the final painting, so choose colors that could be useful if revealed.

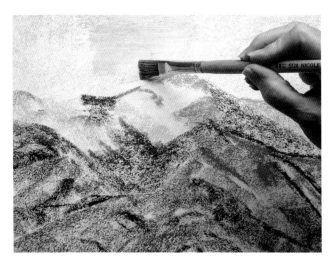

3 **Start With the Lights**
Once you have your surface lightly covered with pigment, begin the underpainting process by washing over the pastel, keeping each color area clean and separate from the others. Start with your lightest colors—if you start with darks, the pigment on the brush will get into the Turpenoid and muddy subsequent colors. Blot or wipe your brush frequently on a paper towel to remove as much pigment as possible before dipping back into the Turpenoid.

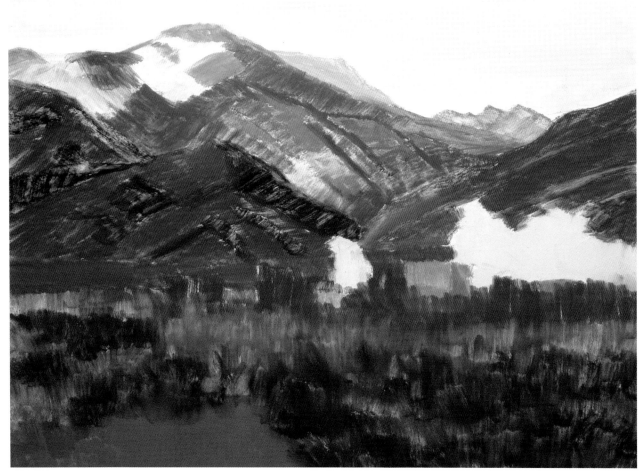

4 **The Final Result**
After the entire surface has been washed with Turpenoid, let it dry completely, or use a hair dryer. If you use a hair dryer, hold it at a slight angle about 4–5 inches (10cm–13cm) away from the surface. Remember, you are applying heat to a flammable liquid! Notice that the colors, which had darkened when wet, dry to the same color you initially applied, only the entire surface is covered. Now that you have your composition laid out and large areas of values and colors identified, you're ready to proceed.

Rubbing and Blending

To rub or not to rub? That is the question. Beginning pastel artists are often inclined to rub the pastels with their fingers to blend colors. While this is tempting, it's often not the best way to proceed.

What makes pastel paintings so luminous is the pure quality of the pigment. The particles of pigment used to make pastel sticks are mixed with a binder, and the resulting paste is formed into a stick. Because the sticks remain dry (as opposed to being suspended in oil or water as in wet mediums), the individual particles retain the faceted edges of the pure pigment. Rubbing the pigment with your fingers can rub off these faceted edges, dulling the colors and creating a muddy look.

However, there are times when blending, not rubbing, can be beneficial to your paintings. For example, a light blending stroke can help move clouds into the distance or smooth the reflective surface of water.

Tapping is another alternative. When you need to marry colors of a similar value together or to soften edges, lightly tap with the ball of your finger. Don't overdo it—a few light taps are all you need.

OVERDOING IT
Overblending can make colors muddy, particularly when blending layers of warm and cool colors or very light and very dark layers. The luminosity of pastel pigment is most visible when colors are applied to the surface and left untouched.

THE BENEFITS OF BLENDING
When you want the sky to be free of visible strokes, blending can be the best approach. Lay down the colors in broad strokes, using the sides of your pastels. Using a clean finger or fingers, gently stroke along the pastel until the surface is evenly blended. Add more pastel if needed and blend again.

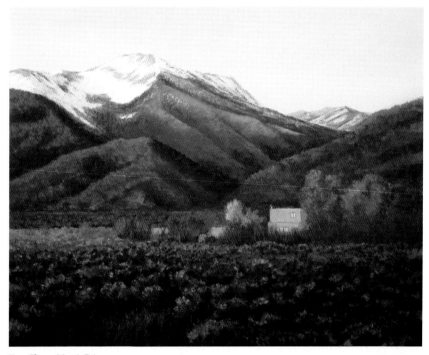

Taos Glow - Maggie Price
Pastel on Richeson premium pastel surface - 16" × 20" (41cm × 51cm)

Lifting Off Color

When you begin a pastel painting with an underpainting, the goal is often to have bits of that underpainting show through. However, enthusiastic application of pastel can sometimes result in covering up more than you'd like. In such instances, you can lift off color to correct your mistakes.

I prefer to use a foam brush over a bristle brush to remove pigment. Foam brushes are inexpensive, come in a variety of sizes and can be found in hardware stores or craft stores, whereas bristle brushes can remove more or less pigment than you want and leave little strokes of hair-like marks on your surface.

Use the corners or edges of your foam brush to lift off tiny areas, and use the broad, flat edge to remove larger areas. If you started with an underpainting, you can lift off all the way to the underpainted surface. It's even possible—with care and a little practice—to lift off bits of one color layer and leave another intact.

When your brush becomes loaded with pastel pigment, rap it sharply against a firm surface to knock off loose dust. If it becomes too dirty, wash the brush, allowing it to dry thoroughly before its next use.

SELECTING A FOAM BRUSH
Though foam brushes come in a variety of sizes, I favor the 1-inch (25mm) brush. To me, this size is easier to handle and provides better control than larger brushes.

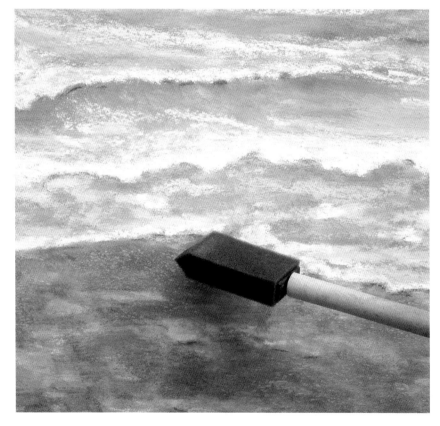

LIFTING OFF COLOR
If you cover up too much of the underpainting, you can lift off small areas of pastel with a foam brush. Tiny bits of color can be removed by using the corner of the brush; larger areas can be removed with the flat edge.

Working From Reference Photos

It's a good idea to paint from life as often as possible, but it's not always an option. In such cases, a camera is a wonderful tool.

Pluses

Not only are reference photos invaluable for artists who live in climates that preclude painting outdoors for much of the year, but they're also a great solution for those who are unable to get out for a number of other reasons.

When working from reference photographs, you can paint any time, no matter the weather, in the comfort of your studio. You don't have to worry about the lighting conditions changing, and you can take time to try different methods for different effects.

Problems

As convenient as painting from reference photos can be, it's not without problems. Often cameras are unable to capture the range of color seen by the human eye. Moreover, pictures can turn out either underexposed or overexposed, obliterating the benefits of natural sunlight. And what if you're not a professional photographer with fancy equipment or computer software programs to correct these problems?

Solutions

Here are a few ideas to help you improve your paintings from photographs:

- **Make notes when you take the photo**, including details like the time of day, the direction of the sunlight and the colors you see in the shadows. Doing so will help you create the most accurate and lifelike painting possible when you get back to the studio.

- **Analyze the color of the sky.** The most common problem in photographs is that the sky is too light—or, less common, too dark or intense a blue. Most often it will appear washed out or nearly white. Look for clues in the photo that tell you what color and value the sky was. Are there reflections of sky color in the water or snow? If they're blue, the sky was probably blue. If there are no reflections, are there strong cast shadows? If so, this indicates sufficient sunlight was present to cast shadows. If there's blue in these shadows, that's another clue that the sky was blue.

- **Analyze the value of the lightest lights.** If the sky in your photo is white and you know it should be blue, then the lightest light values in the photo are probably too light. (The only exception to this may be snow.) Adjust them accordingly.

- **Analyze the value of the darkest darks.** If the lights are too light, there's a good chance the darks are too dark. If your photo is of a sunny day and the shadows are black, the photograph is not reading them accurately. Paint them with slightly lighter values and colors, not black, and consider using several colors of the same or closely related values.

Turning Negatives into Positives

You might be asking yourself why bother painting from photographs with all of the issues that must be taken into consideration? After all, painting from nature or life is the very best way to directly observe the subject, light and shadow that describe form. The easiest answer is there is always an advantage to having reference photographs, even if they are bad photos. A bad photograph invites change, encouraging you to use your imagination and creativity to improve it. When the colors in the photo are clearly wrong, you aren't obligated to copy them; rather, this gives you the freedom to consider all the possibilities of color. And if the subject is a familiar place, you can rely on your knowledge of the place to bring more color into your painting.

Simply turning negatives into positives will help you create beautiful paintings every time, no matter how awful your reference photo may be!

Watch Maggie show you how to work from a photographic reference at http://SunlightAndShadowWithPastels.artistsnetwork.com.

WORKING FROM A BAD REFERENCE PHOTO

This photograph illustrates many of the problems one can encounter when working from reference photos. The sky is white, but the shadows in the snow are blue, which indicates that the sky was blue. The colors in the shadows are almost black rather than the lively color that was likely there in reality. Finally, all the colors of the foliage are somewhat similar.

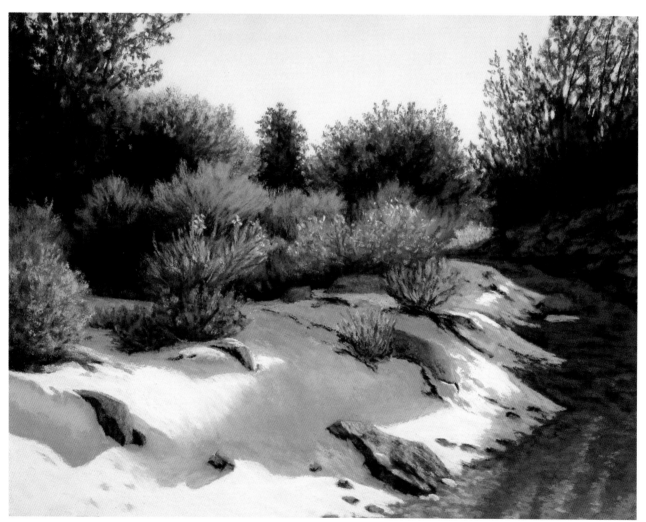

Foothills Trail - Maggie Price
Pastel on Richeson premium pastel surface - 16" × 20" (41cm × 51cm)

BRINGING THE COLORS TO LIFE

In this painting, all the flaws of the photograph were corrected. The sky is now blue, the shadows in the foliage contain interesting colors, and all of the foliage is more colorful.

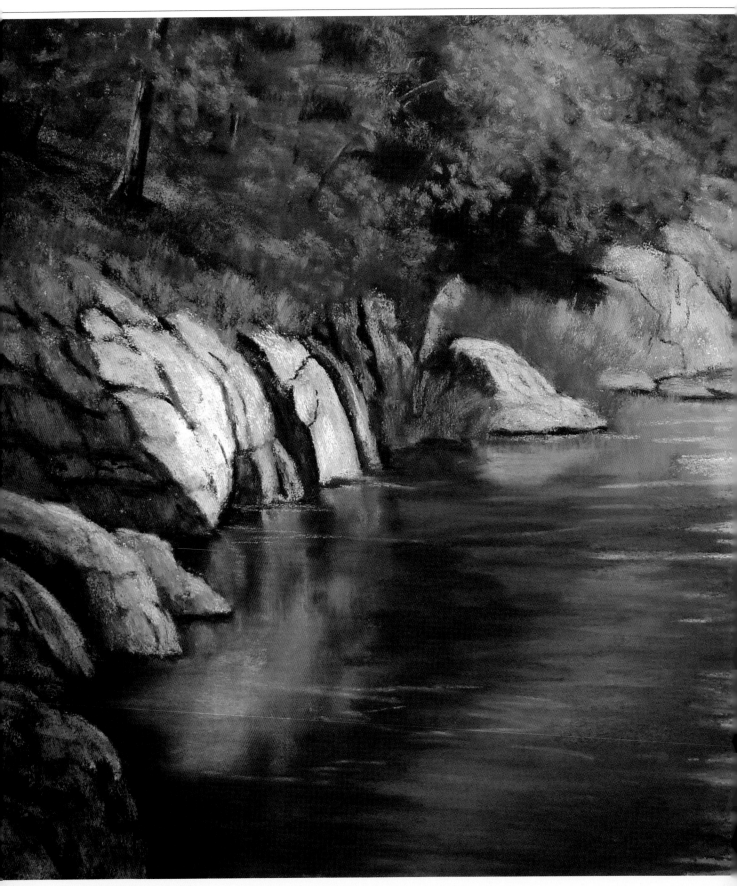

Rocks and Reflections - Maggie Price
Pastel on Richeson premium pastel surface - 16" × 20" (41cm × 51cm)

The Basic Principles of Light and Color

What are you thinking when you reach for a pastel stick? Do you think, "I need a blue here," and then shuffle through an assortment of blue pastels looking for the stick that's just light enough or just dark enough?

There's another way of approaching color selection, and that's to think about value first. You may have read or heard art instructors say, "If you don't have the right color, choose the right value." I say, "Before you think about color, think about value."

Value—or tone—is the relative lightness or darkness of a color and is critically important to the structure of your painting. Strong contrast of light and dark will draw the viewer's eye. In general, grayed or lighter values appear to recede, while stronger dark values appear to be closer.

But there's another important factor as well, and that's temperature— the relative warmness or coolness of a color. Warm colors appear to be closer to the viewer, while cool colors appear to be farther away.

Careful use of both value and temperature will help give your paintings dimension. So when you select a color for your painting, try to think value first, temperature second and finally hue. Instead of reaching for a "blue," look for a "dark cool color," and you may find a cool purple will work just as well or better.

A clear understanding of the values and temperatures of colors in your subject will put you on the right track to a successful painting. But there's another important point to consider. Whether you're painting a landscape outdoors or from a photograph, or a still life in natural or artificial light, the position of the light source is critical in developing a convincing representation of how light, shadow and color describe form. In this chapter, we'll examine all of these factors.

Determining the Range of Values

An interesting contrast of light and dark areas usually serves as the foundation for all of my paintings.

The Importance of Shadow

Understanding value and the intrinsic relationship between light and dark is crucial for an artist. Light cannot exist without shadow, and shadows are always present, working with the light to define form.

The very presence of a shadow provides you with a priceless piece of information necessary to create a successful painting: knowing the position of the sun. Observing the direction and angle of light, and therefore the direction and angle of cast shadows, helps you paint objects more accurately. When you visually survey the natural landscape, you'll see the lightest areas tend to be in the sunlight and the darkest areas in shadow. This sounds simplistic, but it's important to consider when establishing the value range for a painting.

Establishing Value Range

In order for the natural light and shadows in your painting to appear realistic, you must define the value range that you will use, spanning from the darkest dark to the lightest light value within the subject. Some artists who paint from photographs even find it helpful to print a second version of the photo in black and white. This can give you a good feeling for the value range of your subject.

Once you've established the value of the darkest dark and the lightest light, you can consider the general range of values in both sunlight and shadow. Reflected light, or light reflected into a shadowed area, will belong to the light range rather than the shadow range, even though it's within a shadow.

Making a Value Scale

Having a value scale handy is useful in the preliminary determination of value ranges. You can either purchase one at an art supply store or make your own with a range of white, gray and black pastels. Generally, the value of white is assigned the numeral 10, while black has a value of 1. However, the values in your painting may not encompass the entire range—for example, your lightest light might be a 9 and your darkest dark a 3.

Holding the chart next to a reference photograph, you might determine that the strongest sunlight values range from 10 to 7, while the darkest shadow values range from 1 to 3. This initial rough assignment of values will help you keep sunlight light and shadows dark. Remember though, your reference photograph may portray the darks too dark and the lights too light. When assigning values for your painting, make the necessary adjustments.

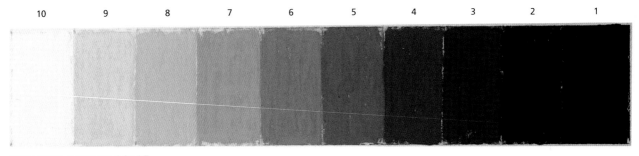

| 10 | 9 | 8 | 7 | 6 | 5 | 4 | 3 | 2 | 1 |

CREATING A VALUE SCALE
You can purchase value scales at an art supply store, or you can make your own from a range of pastels, as shown here.

Squinting: An Artist's Best Friend

One of the best tools for defining values is right on your face—your squinters! Simply narrow your eyes as you look at the subject you're about to paint. Squinting helps you see the big shapes of value masses or the groups of values.

MAKING A THUMBNAIL SKETCH

Sketching a thumbnail of the subject by dividing it into three general value masses—light, dark and mid-value—helps determine an appropriate value range. The dark and middle values are both shadow values, while the light value represents the mass of sunlight. When you develop a painting after creating a simple thumbnail, you can add in smaller shapes, expanding the values from three to however many you see in your subject.

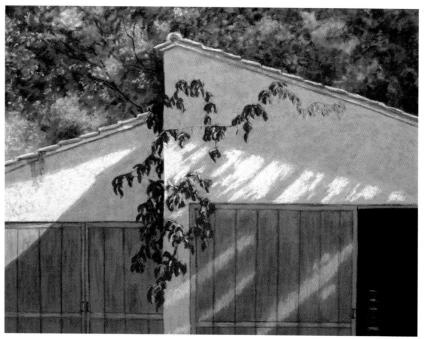

The First Kiss of Fall - Maggie Price
Pastel on terra cotta Richeson premium pastel surface - 16" × 20" (41cm × 51cm)

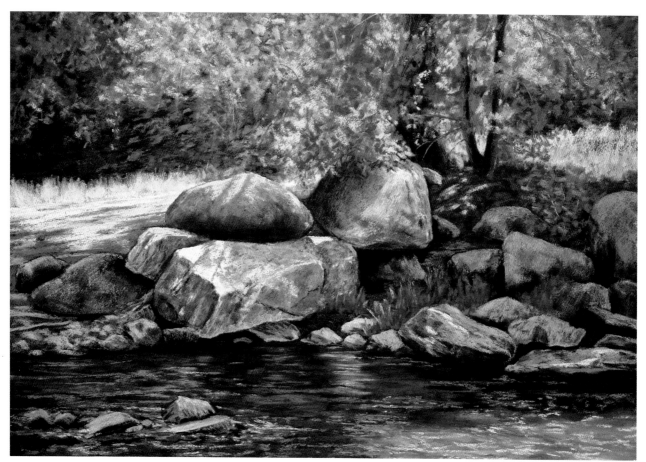

APPLYING THEORY TO PRACTICE

The highlight on the largest rock is the only value that comes close to a 10 in this painting, while the darkest darks are no more than a value of 2. Dappled sunlit and shadowed areas require careful analysis as the painting develops, helping you determine what is in sunlight and what is in shadow, and what values to assign to each object or area.

Colorado Creek - Maggie Price
Pastel on Richeson premium pastel surface
18" × 24" (46cm × 61cm)

Achieving Realistic Whites

Though white objects are usually the lightest values in a painting, they are rarely painted using pure white. Using pure white often results in an unnatural look. This is because the sun's light—or the reflected light bouncing off other objects—tints the color, coating it with subtle traces of either warm or cool hues. The position of the sun and the angle of its rays, together with other atmospheric factors, will determine the exact color of this tint.

Instead of white, try creating the impression of white with very light values of colors such as yellow, pink, orange, and even green or blue. By using one or more of these colors and laying them in adjacent to each other with short strokes, you're sure to create some luminous whites.

Mission Light - Phil Bates
Pastel on mounted Wallis museum–grade sanded pastel paper - 12" × 9" (30cm × 23cm)

Using Tints and Shades

Pastel manufacturers generally make a number of tints (lighter colors) and shades (darker colors) of each hue. Look for groups of tints of the same value to create dynamic whites and shades of the same or closely related values to create lively shadows.

CREATING CONVINCING WHITES

The brightly lit white wall was created with a combination of tints, from yellow-white and peachy white to greenish white and orange-white. Note that the majority of colors used are warm, though the shadows contain a mix of cool colors and the warm colors of the reflected light.

Creating Believable Blacks

Much like white, black seldom exists in pure form in paintings. Black shown in full sunlight may appear much lighter than you expect. For example, if you look at the roof of a black car in full sunlight, you'll notice how much closer its value appears to light blue, green or violet than to black. Take the time to observe the color a black object appears to be rather than just relying on your knowledge that it's black. In addition, different black materials and surfaces—black metal versus black wood—reflect sunlight differently, so capture these discrepancies in your paintings.

Using Dark Black

The value of black or close-to-black colors in full shadow is usually the darkest value in a painting. Still, adding hints of colors similar in value keeps these areas from being "black holes" in your painting. A few areas of really dark black are sometimes appropriate though. When I paint rocks, I always look for places to use a rich, unadulterated black. I call these my "spider holes"—places so dark and deep you would never want to reach into them. No light reaches into the depths of spider holes, so they can be painted totally black. Just don't put in too many!

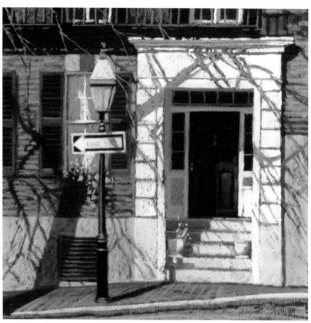

Louisburg Shadowplay - Liz Haywood-Sullivan
Pastel on black Canson Mi-Teintes paper - 16" × 16" (41cm × 41cm)

PAINTING BLACK SURFACES THAT FALL IN LIGHT
Different black materials and surfaces reflect light differently. Note the discrepancies between the color of the door, the light pole and the one-way sign. Variations between a metal surface, a plastic surface or a wooden one can dramatically affect the perception of color.

PAINTING BLACK OBJECTS THAT FALL IN SHADOW
Although this dark rock in deep shadow is almost black, there are still subtle hints of color to better define the rock's form.

Look to the Edges

When painting black objects, pay special attention to the edge between the shift from sunlight to shadow. While angular objects may reflect that change as a hard line, rounded surfaces may need to be painted with halftones.

Sun Sculpted - Colette Odya Smith
Pastel on Rising 4-ply museum board - 20" × 20" (51cm × 51cm)

Understanding Temperature

Artists often refer to a color as "warm" or "cool" in temperature, but what exactly do these terms mean? Generally speaking, cool colors are those that fall into the blue range, while warm colors fall into the red and yellow ranges. The perception of a color as warm or cool is a crucial, sometimes complicated component of color theory. While it's not necessary to master this subject, understanding the basics of temperature will greatly enhance your paintings.

Complementary Combinations

When looking at complementary pairs on the color wheel, notice the split between warm and cool: Red is warm, while green is cool; yellow is warm, while violet is cool; and orange is warm, while blue is cool. As you move into secondary and tertiary combinations, it gets more complex. Analyzing the composition of the colors will help you determine whether they belong on the cool side or the warm side. For example, red-violet has more warm components (red plus the components of red and blue in violet equals two warm colors and one cool color), while blue-violet has more cool (blue plus the components of red and blue in the violet equals two cool colors and one warm).

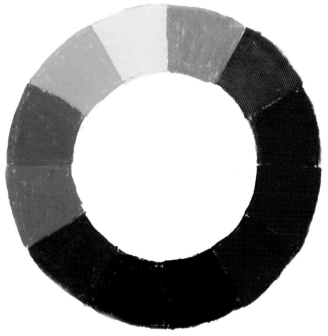

THE COLOR WHEEL
This simple color wheel shows the primary, secondary and tertiary colors. To choose a complementary pair, select colors directly opposite each other on the wheel, such as blue and orange. You may also find interesting combinations by selecting the "neighbors" of one color, such as blue and red-orange or yellow-orange.

THE PERCEPTION OF COLOR
In placing colors in your painting, take into account that the perception of a color is affected by the surrounding colors. A green mark in the middle of a red field may appear cool, but the same green may appear warm when surrounded by blue. Green is an ambiguous color because it's composed of a warm (yellow) and a cool (blue); the variation in amounts of one or the other component can cool or warm it. If you want to make a specific color appear cooler, consider warming up the colors around it.

Suggesting the Cool Tones of Morning Light

When I'm painting outdoors or from a photograph taken outdoors, one of the first questions I ask myself is *What color is the light?* A person who is not an artist might think this is a silly question, but an artist learns to analyze and understand the many colors of light—all of which are tied strongly to the time of day.

Moods of Morning Light

Morning light, which tends to be cooler in temperature, bathes landscapes in lovely shades of blue and lavender. Using these cool hues in your paintings is a great way to create a soothing, peaceful or mellow mood. However, it's important to note that different viewers will respond differently to color choices. That is, the painting may evoke an entirely different feeling from one viewer to the next.

Though the light in Richard Lundgren's *Amelia Island Flowers* is undeniably cool, notice how the cheerful flowers in the subject keep the painting from becoming too cold or sterile. Small touches like these can make all the difference in your compositions.

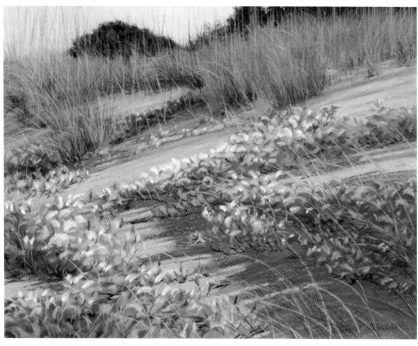

Amelia Island Flowers - Richard Lundgren
Pastel on white Ampersand Pastelbord - 11" × 14" (28cm × 36cm)

PAINTING IN MORNING LIGHT
The reference photo for this painting was taken around 7:30 a.m. on a relatively cool day. Note how the color of the sand on the dunes has lavender tones throughout, with deeper lavenders and purples in the shadows.

Capturing the Warmth of Midday Light

Upon first glance, we might think of light as white. Indeed, some forms of artificial lights do give off a white glow. But natural light from our sun, which is a yellow star, often contains a hint of yellow. This is particularly true in the strong midday light when the sky is clear.

To achieve a more realistic midday light, oil painters often add touches of yellow to their white paints. However, a pastel artist painting a white object in midday light (e.g., a cloud) can avoid the process of blending or layering colors by simply laying down a very light pale yellow in place of white. If you don't have a pale enough yellow in your collection, don't worry; lay down a light yellow and then skim white over it.

When painting landscapes in the hot light of midday, choosing colors that have yellow in them not only harmonizes the painting but gives a feeling of the heat of the sun. Select greens that contain more yellow than blue, and keep your highlights in the yellow range.

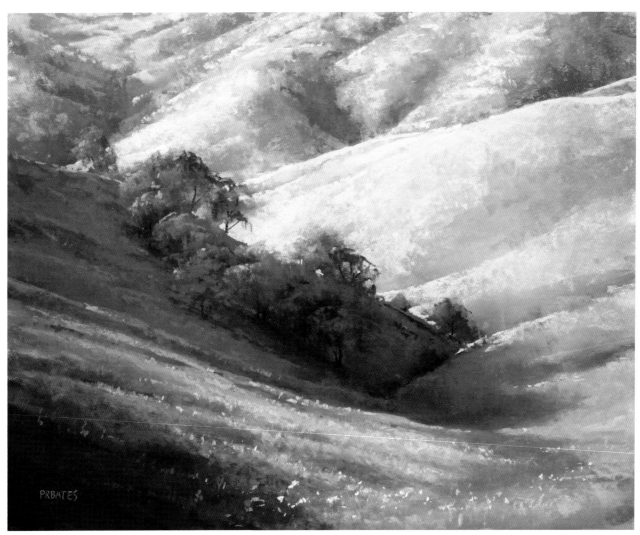

PAINTING IN MIDDAY LIGHT
The hot light of early afternoon is captured in this painting not only in the strong yellows, but in the use of yellow-greens. Note how the artist has selected grayed blues for the distant shadows, and lavenders and oranges as well as green in the close foreground shadows. Using these colors not only creates a sense of distance, but maintains the feeling of strong sunlight throughout the painting.

Warm Afternoon - Phil Bates
Pastel on Wallis sanded pastel paper
16" × 20" (41cm × 51cm)

Re-creating the Glow of Late Afternoon Light

Possibly the easiest color of light to identify is that of the late afternoon, when the setting sun casts an orange or reddish glow. When you paint a subject in this light, include a hint of the light's color throughout the painting. Doing so will create harmony in your painting and unify it as a whole.

Using touches of complementary colors is also a great way to strengthen your composition. By simply including the color opposite the color of the light, you can create visual contrast. For example, if you're painting a subject that's basking in the rich, warm orange light of the setting sun, adding hints of blue throughout will help keep your composition interesting and tie it together.

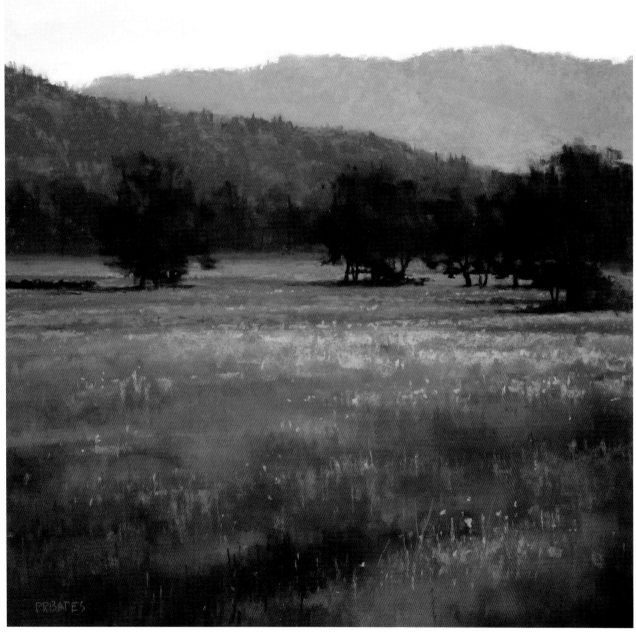

PAINTING IN LATE AFTERNOON LIGHT
The orange glow of the setting sun is present throughout this painting, with touches of warmth everywhere, including the distant blue mountains. Note how the artist has painted the sky yellow-orange and how effective this is for portraying the time of day.

Melrose Evening - Phil Bates
Pastel on Wallis sanded pastel paper
16" × 20" (41cm × 51cm)

Rendering the Effects of Midday Light

The type of light being cast onto an object can change its appearance drastically. As you've seen, morning light cools color, pushing the shadows to blue, while late afternoon sun tints color with a fiery glow. Midday light has an equally remarkable effect on color, intensifying highlights and gently warming the surface of objects. This is especially evident when painting the human figure in midday light.

In this demonstration, you'll see just how dramatically the midday sun can affect the color of skin, yielding beautifully deep, rich and warm tones.

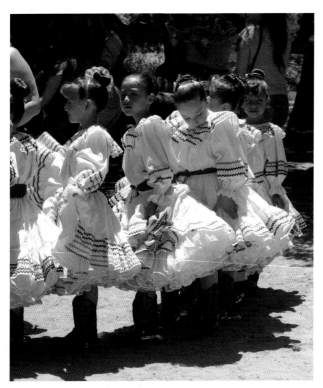

REFERENCE PHOTO
The strength of this photo is the midday light shining on the girls' faces and their dazzling white costumes. The challenge is to compose a painting that focuses on these elements while excluding extraneous data. To do this, reduce the background to a warm abstraction and omit the partial figure on the far left.

Materials

SURFACE
14" × 11" (36cm × 28cm) white Ampersand Pastelbord

PASTELS
Background and shadows: burnt sienna, dark red earth, light blue-violet, light tan, middle-value blue-violet

Boots: dark red earth, light blue-violet, light gray

Dresses: dark red earth, light pink, pink, two values of blue-violet, white, yellow-white

Faces, legs and hands: dark burnt umber, flesh, light blue-violet, light ochre, light orange, lighter red-orange, middle-value burnt sienna

Underpainting: blue-violet, dark burnt umber, dark umber, dark red earth, light ochre, light tan, middle-value burnt sienna, two light values of blue-violet

PASTEL PENCILS
Boots: bright red, burnt umber, white

Dresses: bright red, middle-value blue-violet, red, turquoise, violet, white

Faces, legs and hands: blue-violet, bright orange, dark burnt umber, dark red earth, dark umber, light red-orange, orange, red

Highlights: bright orange, high-key yellow, red, sienna, yellow, white

Shadows: blue-violet

OTHER
1-inch (25mm) and ¼-inch (6mm) synthetic watercolor brushes; 11" × 14" (28cm × 36cm) 50-lb. (105gsm) white drawing paper; mineral spirits; nos. 2, 2B, 4B and 9B pencils; paper towels; pencil sharpener; sandpaper block; SpectraFix fixative; tape

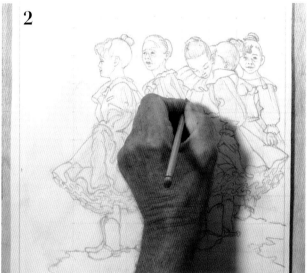

1 **Complete the Sketch**
Make a full-sized sketch of the painting on a piece of 50-lb. (105gsm) drawing paper using your 2B and 4B pencils. While this can be done freehand, it's easier to scale your reference photo into a convenient size. 1⅛-inch (3cm) squares provide the proper proportions. Use a vertical format and position the figures far enough to the right to prevent the viewer's eye from being led out of the left margin.

Make the second figure from the left more dominant by enhancing her look of concern. Maintain the feeling of spontaneity by varying the interval between the figures and the directions the heads are turned.

To enhance the sense of a bright sunny afternoon, surround the shadows under the figures with light. Darken the values from the lower edge of the skirts toward the upper third of the sketch, suggesting a background in shadow. Grade to a slightly lighter value at the very top where the warmth of the sun penetrates the background.

2 **Transfer the Drawing**
Blacken the back of the drawing with a 9B graphite pencil. Then tape the drawing over the white Ampersand Pastelbord and use a no. 2 pencil to trace the drawing onto it. Carefully lift the taped corners to check that you've traced all the lines.

Reinforce any weak lines, and spray the drawing with SpectraFix casein-based fixative. Rub a nonessential part of the drawing with your finger. If it smears, apply another coat of fixative.

3 Underpaint the Background

Using the sides of your pastel sticks, lightly lay in the background colors. Avoid filling the tooth of the support. Begin with dark burnt umber followed by middle-value burnt sienna, light tan and a little blue-violet.

Next, brush the pastel into the surface using your 1-inch (25mm) flat brush and a small amount of mineral spirits. Use your ¼-inch (6mm) brush when working around the fine details like the faces. Start with the lighter areas and work to the darker values.

Keep a paper towel on hand to wipe the brush between colors. The color will darken when wet, but will dry back to the original value in a couple of minutes.

4 Underpaint the Figures

Using hard pastels, color the faces with light ochre and middle-value burnt sienna. Color the hair with dark umber. Use the same colors for the legs and hands. Leave the highlights on the skin and hair mostly unpainted. This is where the strongest sunlight hits, and the white surface helps keep those values light.

For the skirts, use hard pastels of two lighter values of blue-violet to color in the shadowed areas. Use a dark red earth to color the boots.

Using the same brushes from step 3, work in the colors. First wet the faces, blending the color slightly into the unpainted highlights. Do the same for the hands, legs and hair. Use mineral spirits to paint over the red of the boots. Allow your painting to dry.

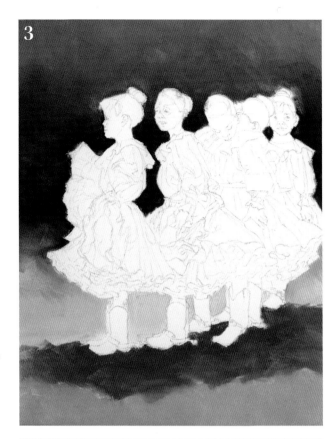

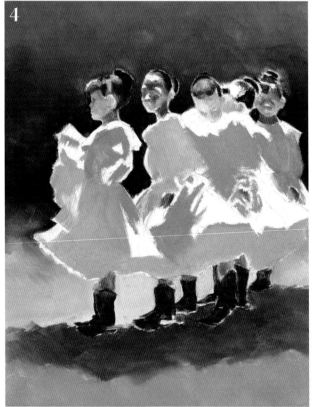

Express Yourself

When doing the demonstrations in this book, remember to have fun, experiment and play with color. If you don't have a hard pastel in a specific color, a soft one will work just as well. There are no rigid rules. Even when following a step-by-step, you have the freedom to add colors or not. There is always latitude for personal expression.

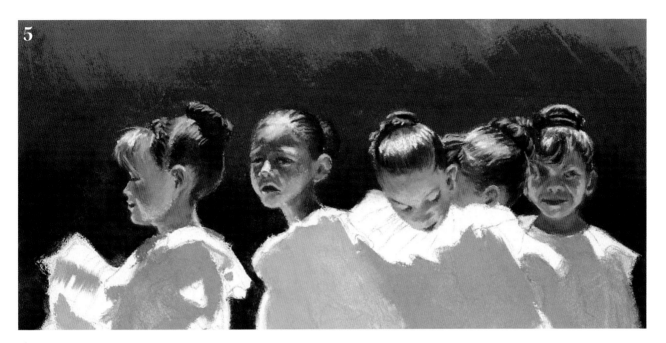

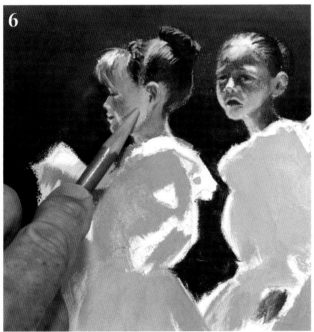

5 Add Facial Features

Define the faces using the tips of your pastels. To get a sharp point, begin with a pencil sharpener and then finish the point using a sandpaper block. Establish the darks of the eyes with a dark burnt umber. For the lips, use a dark red earth pastel pencil. The ears are semi-transparent in sunlight, so use a lighter red-orange pastel pencil.

Refine these critical details by working over the colors with lighter tones. Render one face at a time, but use the same pastels for all: middle-value burnt sienna, light ochre, light orange, flesh and a little light blue-violet for the shadow areas around the nose, upper lip and temples.

6 Place Highlights

The highlights are critical to create the impression of bright sunlight. Use a soft yellow that is almost white. This will create a stronger feeling of sunlight than pure white. Blend the facial colors and show the contours of the cheeks, jawline and eyebrow ridge using the edge of the pastel pencil. Notice areas of reflected light from the dresses on the jawlines and cheeks. These reflected lights intensify the sense of bright sunlight on the figures. An easy way to achieve these critical highlights is to use a sharpened white pastel pencil to slightly lighten the values in these areas. The ears are mostly highlighted with bright orange, high-key yellow and red. The hair is mostly dark umber with sienna, white and high-key yellow highlights.

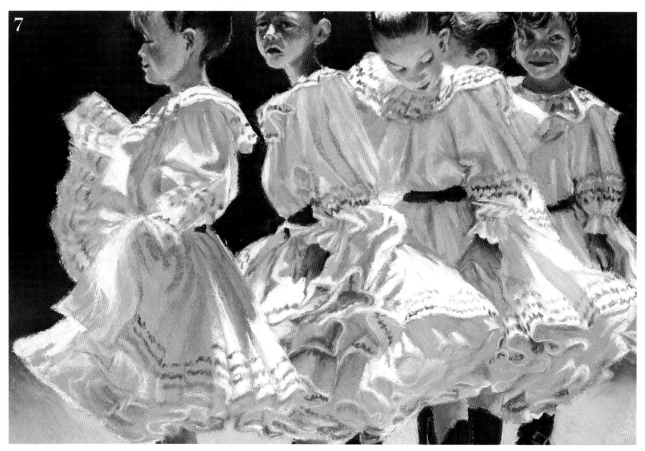

7 **Paint the Dresses**

Keep your rendering impressionistic with strong shadows and highlights. Start by refining the shadowed areas to emphasize those areas in direct sunlight. Indicate the edges in sun with white, particularly the collars. Use a hard and soft white pastel and a soft yellow-white pastel to emphasize the brilliance of the sun. Reinforce the dark contours of the folds and creases with a middle-value blue-violet pastel pencil, then soften the contours with two values of blue-violet, using both hard and soft pastels. Blend the colors with the side of a sharp pastel pencil. Use a soft light pink pastel to indicate reflected light where one dress reflects upon another.

Notice the petticoats also reflect the warm color of the ground. Lightly glaze pink over these blue-violet areas with the side of the pastel stick. Then, with a white pastel pencil or hard white pastel, suggest the satin trim of the petticoats. The red sash is painted with a hard dark red earth pastel and a bright red pastel pencil. Suggest the various colors of the trim on the sleeves, skirts and collars with pastel pencils of red, violet and turquoise.

8 **Add Finishing Touches**

Indicate the shadows on the legs by glazing with a blue-violet pastel pencil.

Paint the boots with the same reds used for the sash. Indicate the straps with a burnt umber pastel pencil, and place the highlights with a hard, light gray pastel and a white pastel pencil. Suggest the spurs with a few strokes of light blue-violet.

The shadow cast by the figures includes both the direct light of the sun and the reflected light off the boots. Begin by reinforcing and defining the edges with a hard burnt sienna. Glaze over the sienna with the side of a hard dark red earth pastel and a middle-value blue-violet pastel. Work over the light areas of the ground with the same light tan pastel used for the underpainting.

Go back into the background with the same pastel used for the underpainting to soften the transition from ground to background and to touch up any areas that look thin. Last, lightly glaze a little light blue-violet over the heads of the figures.

Red Boots - Richard Lundgren
Pastel on white Ampersand Pastelbord - 14" × 11" (36cm × 28cm)

Painting a Landscape in Late Afternoon Light

The reference for this painting is part of a mountain range that I can see from the front of my house. Over the last few years, I've watched the light change each day. In the morning, the sun is behind the mountain, and the entire range is a flat blue silhouette. In midday, some of the shapes begin to emerge. Only the late afternoon light dramatically highlights and shadows the shapes of the foothills and layers of the mountain range, revealing the formations hidden earlier in the day. Whether you choose to paint early morning light or late afternoon light will depend on the time of day at which your subject is best illuminated.

Materials

SURFACE
15" × 24" (38cm × 61cm) black Richeson premium pastel surface

PASTELS
Sky: dark blue, dark blue-gray, light blues, light blue-green, light grays, light pinks, light turquoise, middle-dark blue, middle-dark blue-gray, middle-value blue-gray, middle-value reddish gray, very dark blue

Mountains: two close values of dark rusty red, middle-value orange, two lighter rusty reds

Shadows: dark blue, dark brown, dark gray-green, eggplant purple, middle-dark brown, middle-value grayed reddish brown, reddish brown, very dark blue

Snow: dark blue-gray, middle-dark blue-gray

City lights: bright middle-value orange, bright orange, dark blue, middle-value purple, very bright yellow, very light peachy yellow

Foreground: middle-dark blue, middle-dark gray-green, middle-light gray-blue, middle-value brown, middle-value gray-green

PASTEL PENCILS
Sketch: light blue, red-orange

REFERENCE PHOTO
This photo was taken in late afternoon on a winter day. There are still patches of snow in the shadows on the mountain, and a storm is just passing. The position of the sun is low behind the viewer and to the far right, creating the sharpest edges and strongest contrast of shapes on the mountain at the far right of the range.

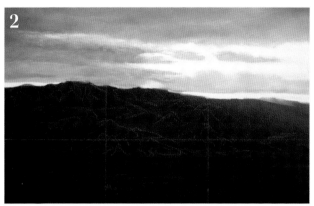

1 **Complete the Sketch**
Place a simple grid with three horizontal and vertical sections on your photo and painting surface. To keep the grid lines from being confused with the drawing, use a light blue pastel pencil for the grid and a red-orange pencil for the drawing. Draw the major shapes and lines of the composition, ignoring small details. One of the beautiful things about pastel is that you can continue drawing all through the process, so the initial sketch can be simple.

2 **Paint the Sky**
To keep the surface clean and to focus on the cloud shapes, paint the sky with your surface upside down. Block in the shapes of color using soft or medium-soft pastels. Start with the darkest colors of blues and blue-grays, then lay reddish gray over the blue where the warm light

illuminates the clouds. Next, move into the lighter values of grays, pinks and blues. Finish the lightest areas using light blues, light blue-green and light turquoise. Lightly finger blend the smoothest areas of the sky, being careful not to muddy the colors. Once all shapes are blocked in, turn the board right-side-up and make corrections as needed.

3 **Define the Mountains**
Select soft pastels in two close values of dark rusty red, two lighter rusty reds and a middle-value orange. Using the sides of the pastels, block in areas of sunlight, keeping the lightest and brightest colors to the right and moving toward the more muted darker values as the light crosses to the left. Then, using long steady strokes, place darker values to indicate the edge of the foreground land mass where it meets the mountain.

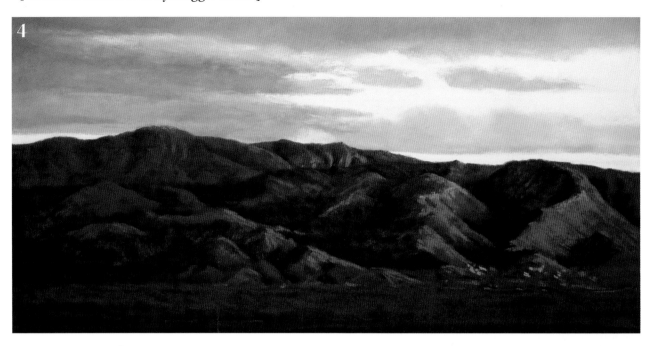

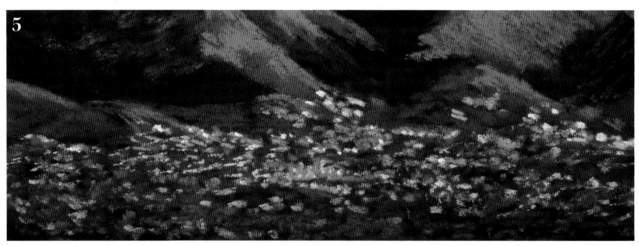

4 Lay in Shadows on the Mountain
Select an assortment of very soft to medium-soft pastels in very dark blue, dark blue, dark brown, middle-dark brown, reddish brown and eggplant purple. Beginning with the eggplant purple, lay in the shapes of the deep shadows and crevasses on the mountain. Moving on to the next lightest values (dark blue and brown), continue laying in the shadow shapes, holding your pastels on their sides and skimming color lightly over the surface.

For the snow in the shadows, use a dark blue-gray and a middle-dark blue-gray, skimming a light layer here and there in the deepest shadows. Be careful not to get the value of the snow too light. If it appears too strong, tap it lightly with the tip of your finger to push it into the other colors.

If the halftone areas need to be softened, use a middle-value grayed reddish brown. Don't overdo the use of the halftone color though, as this could eliminate the strong contrast between light and shadow. Scumble a hint of dark gray-green to select shadowed areas. You want to keep this subtle, so don't add too much color.

5 Dot in the City Lights
At this time of day, the sun hits the windows of the buildings in the city and the houses that line the foothills. Using soft pastels in bright middle-value orange, very bright yellow, very light peachy yellow and bright orange, quickly dot in these lights. Go back into those same areas with a middle-value purple and a dark blue to put in some shadows. Squint at the photo and look for the large areas of light and shadow. Don't worry too much about getting the exact colors in the exact places; rather, create a representation of lights.

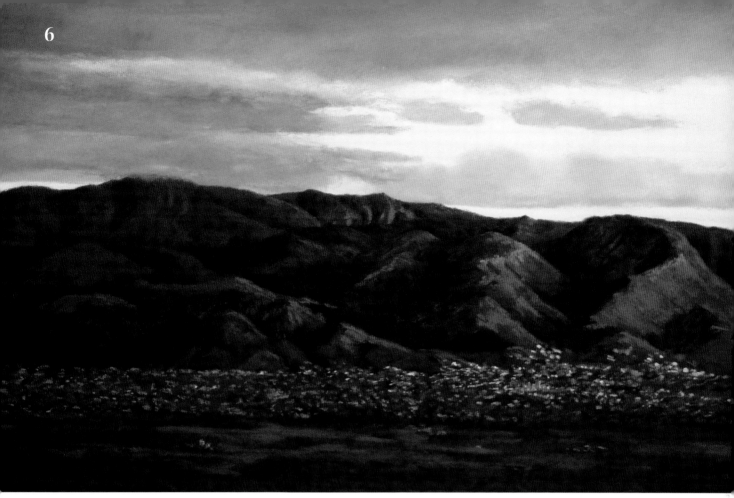

South Peak Sunset - Maggie Price
Pastel on black Richeson premium pastel surface - 15" × 24" (38cm × 61cm)

6
Add Finishing Touches
Using soft pastels in middle-value gray-green, middle-value brown, middle-dark blue, and middle-dark gray-green, lay in the foreground, squinting to see the pattern of the large flat areas and the areas of mottled color indicating foreground trees. Note that the edge where the buildings mostly stop is more distinct on the right where the sun is stronger. With a middle-light gray-blue, indicate the larger buildings in the mid-foreground.

Now step back and look at the painting, looking for problem areas. You may need to refine edges, sharpening those in the mountain shapes on the right where the sun is strongest and muting them as you move to the left side of the painting. Finally, take the reddish gray you used in the clouds and pull a little cloud down over the highest peak, tapping it with your finger to soften as needed.

Tips for Working on a Black Surface

A black surface is ideal when your subject has a great deal of shadow. This creates an opportunity to lay in the patterns of light first and to let the black surface initially represent shadows. It can be a lot of fun, but there are a few things to remember:

- **Draw with a light-colored pastel or pencil.** If you need to make a correction, erase with a kneaded eraser.

- **Lay in the pattern of light first.** In pastel, you generally begin with dark values and move to the lights. When you work on black, start by laying in the major light value shapes. You can save the strongest highlights until the end.

- **Put down a few color notes of your darkest darks.** You may be surprised to find your darkest darks actually appear darker than the surface. However, if the darkest value in your subject is lighter than the surface color, it's important to lay these in early so the painting doesn't go too dark.

- **Block in the middle values last.** Then, check to see if your value structure as a whole is accurate. If not, make adjustments.

Mountain Wildflowers - Maggie Price
Pastel on Wallis sanded pastel paper - 16" × 20" (4cm × 51cm)

Observing the Color of Light

In addition to the time of day, a number of environmental factors can alter the color of natural light. Whether these changes are subtle or significant, learning to recognize and portray these nuances will not only enhance your paintings, but also make them more believable. In this chapter, we will discuss three particular environmental elements that often affect the color of light: air quality, altitude and weather.

Air quality is affected in a natural way by humidity; the more humid the climate, the denser the air and the bluer or grayer objects in the distance become. This bluing or graying of objects in the distance is called "aerial perspective." On a humid day, trees may have a tinge of blue a block away, and hillsides close to the viewer may be blue-gray and indistinct. The opposite is true in very dry weather.

Air quality is also affected by pollution. Smoke and pollution often cause the light to be tinged with orange or brown, creating spectacular sunsets.

Altitude thins the air; the higher the altitude, the less oxygen and, quite often, the less humidity. The light is often crystal-clear with a cool sparkle in the morning and midday. Dark colors do not fade into blue-gray as rapidly with distance. Trees on a mountaintop miles away may be crisply defined. The artist has to compensate for this in order to make distant objects appear truly distant.

Finally, weather can greatly transform the color of light. Overcast skies can dull or gray the light, while storms sweeping in lead to dramatic changes in color. Likewise, rain and snow can soften, mute, cool or warm the light, with each different possibility creating a different mood.

Like so many things we learn as artists, the more you study the color and atmospheric qualities of light, the easier it will become to portray it in your paintings.

The Effect of Aerial Perspective

Simply put, the farther away an object or land mass is, the bluer and grayer it becomes. This is called "aerial perspective," and careful attention to this tells the viewer what's close and what's far away.

Conveying Distance

While it's not necessary to understand the physiology of the eye and how its rods and cones perceive the wavelengths of color, understanding a few generalities will help convey distance in paintings.

Imagine yourself looking across a field to distant mountains. In the foreground, you can distinguish all the colors of the spectrum. However, as you look farther and farther away, you are less able to perceive certain colors. Reds and yellows vanish first, while blues can be seen at great distances.

To help the viewer understand the distance in your painting, use cool blues and grays to indicate objects farther away and warm colors such as reds, oranges and yellows to suggest closer objects.

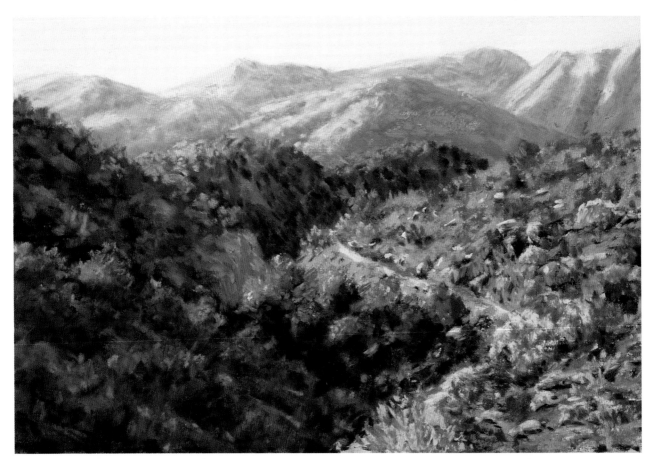

AERIAL PERSPECTIVE CREATES A FEELING OF DISTANCE
The aim of a painting is to depict three-dimensional reality on a two-dimensional surface. Accurate use of aerial perspective helps show what is close and what is far away. Always remember that cool colors tend to recede while warm colors tend to appear closer.

Hiking the La Luz Trail - Maggie Price
Pastel on Wallis sanded pastel paper
9" × 12" (23cm × 30cm)

The Impact of Air Quality

The quality of air can affect the color of light in many ways, so it's important to carefully observe your subject in order to portray atmosphere and aerial perspective accurately.

When such elements are present in the air, objects in the distance become lighter or cooler in value and temperature, and edges are softened.

The Coloring of Light

Air quality has great impact on the color of light. Pollutants like dust and smoke, and atmospheric haze and humidity can significantly alter both the appearance of color and aerial perspective.

Considering Different Factors

The visible impact of air quality greatly depends on what exact factor is affecting the quality of the air. For example, pollution lends an orange or rusty tinge to distant objects, slightly warming grayed tones. On the other hand, atmospheric haze tends to cast a bluish tint on objects.

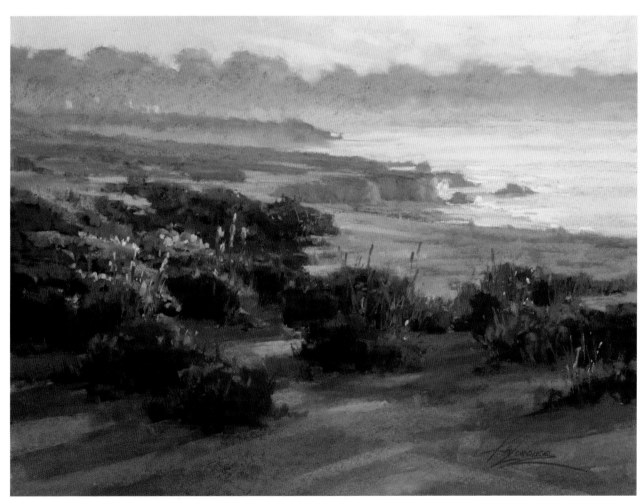

THE QUALITY OF AIR AFFECTS THE COLOR OF LIGHT
We can tell by the long shadows that the sun is low in the sky, and the warm tinge to the light indicates that it is afternoon or evening. The humidity and pollution in the air affects the value of the distant trees, graying them more than on a crisp clear day. The artist has softened the edges of the land masses, shoreline and trees in the background to accurately portray the quality of the air and light.

Spyglass Glare - Kim Lordier
Pastel on Belgian mist Wallis sanded pastel paper
18" × 24" (46cm × 61cm)

The Influence of Altitude

Each of these conditions has a unique effect on the color of light. Closely observe the setting before choosing your color palette.

Painting Higher Altitudes

At high altitudes, there is generally less humidity, dust and pollution in the air than at lower altitudes. This means that objects appear more clearly defined, even at great distances. As a result, when painting objects in high altitudes, you'll need to artificially gray or blue distant objects to give the viewer an understanding of the depth of the scene.

Red or other warm colors in the distance can pose particular problems at higher altitudes. To make the distance clear to the viewer, scumble in lavenders and blues to mute the strength of the distant warm colors.

Painting Lower Altitudes

At lower altitudes, humidity, mist and denser air can soften and cool the light. Humidity is created by tiny particles of moisture in the air. Light bounces from one particle of moisture to another, imparting a bluish haze.

The closer you are to the ocean, the likelier there is to be more humidity, especially on a still day. When humidity is extremely high, it becomes fog. Fog obscures the light to varying degrees and changes its color entirely.

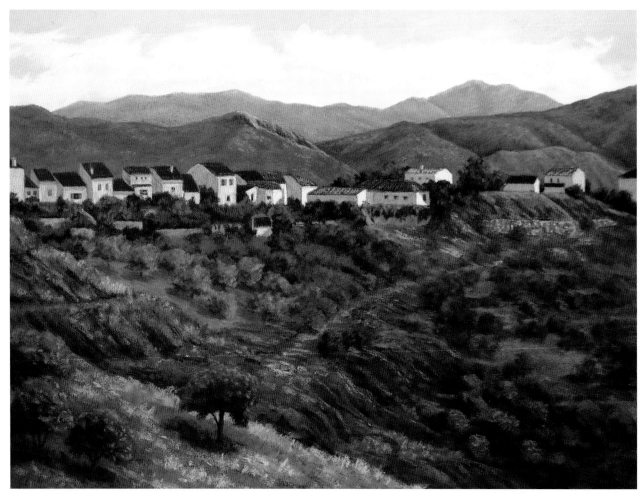

CREATING DISTANCE AT HIGH ALTITUDES
Warm tones dominate this painting of the Andalucian mountains of southern Spain. To make the distant mountains look as far away as they actually were, the blue tones had to be emphasized. Note the value difference between the farther mountain range and the one closer; the darker colors bring it forward, as do the richer earth tones.

Approaching Cartajima - Maggie Price
Pastel on terra cotta Richeson premium pastel surface
18" × 24" (46cm × 61cm)

PAINTING EARLY MORNING LIGHT AT SEA LEVEL

The reference photo for this painting was taken early in the morning when the sun was still low in the overcast sky and the temperature cool. The effect of the light muted by the clouds and humidity has softened the description of the vegetation on the sand dunes. In full sun, this vegetation would be grassy green, but the color and temperature of the low light has turned it blue and olive-brown.

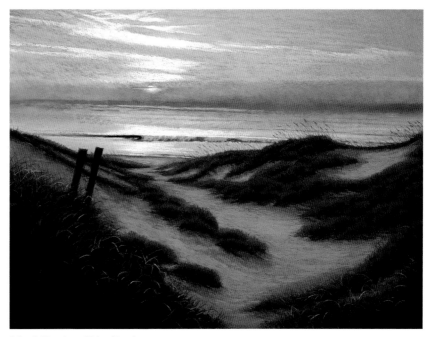

Atlantic Morning - Richard Lundgren
Pastel on gray Ampersand Pastelbord - 18" × 24" (46cm × 61cm)

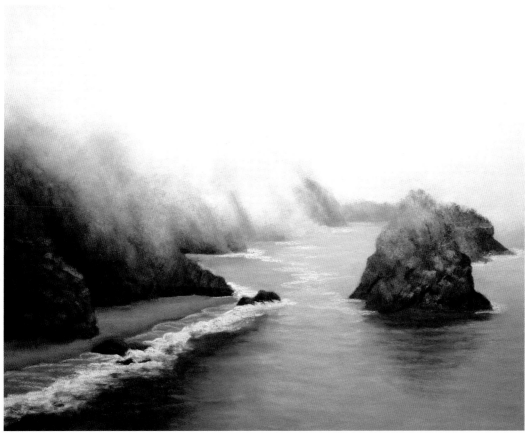

PAINTING FOG

Like clouds, at first glance you might think you see white, but fog is made up of many colors. The fog was painted with light gray, blue, turquoise, lavender and yellow. Because the light is diffused as it comes through the heavy humidity, there is no obvious light source, and there are no cast shadows.

Emerging - Maggie Price
Pastel on shale Richeson sanded pastel surface - 16" × 20" (41cm × 51cm)

The Consequences of Weather

Weather conditions can transform the color of light.

Cloudy Skies

Clouds play a major role in the appearance of the sky. They can block the sun, entirely or partially; they can reflect the sun's light and bounce it around; or they can cast enormous shadows on land, defining contours and changing hues. When clouds are lit from the side or below, as from the setting sun, they can actually reflect light back onto the land, giving distant objects a warm glow. And in other circumstances, warm colors on the land may even reflect upward into low-hanging clouds.

Rain

Rain is endlessly fascinating. It affects the color of the light both as it's falling and after it ceases. Colors may be muted and softened; dark colors may become intensely dark. Edges are lost, and colors gray and recede rapidly. Following a rain, wet objects reflect light; wet streets mirror the color of the sky or reflect nearby objects. Dark objects, which might not pick up any reflected light when dry, shimmer with color. Details sparkle with light or are lost in wet shadows. Colors remain grayed if the sky stays overcast following a rain; if the sun comes out, the clear, dust-free atmosphere following a storm illuminates the landscape more brightly than before.

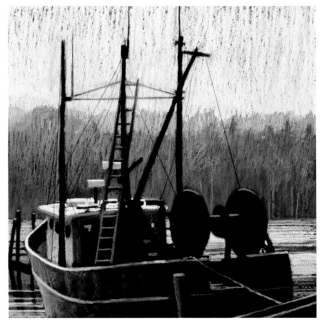

Day Off - Liz Haywood-Sullivan
Pastel on black Canson Mi-Teintes paper - 16" × 16" (41cm × 41cm)

INDICATING FALLING RAIN
The falling rain is suggested by visible strokes of pastel. The color of the sky is reflected in the water and on the roof of the boat. Details that may have been clear on a sunny day are now lost in darker areas.

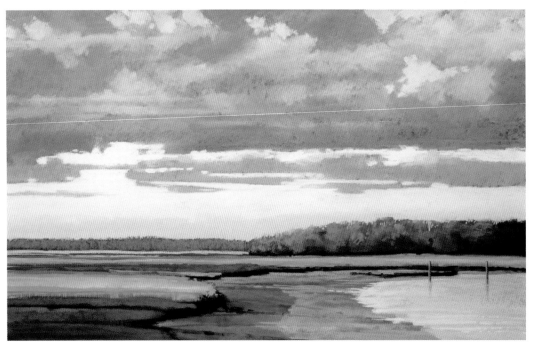

CAPTURING OVERCAST SKIES
Late afternoon light casts long shadows, mingling with cloud shadows on the ground. The sky colors transition from pink near the land to pale gray-blue and deep cerulean blue above the clouds.

Fall on the North River
Liz Haywood-Sullivan
Pastel on Wallis museum-grade sanded pastel paper
24" × 36" (61cm × 91cm)

Snow

When the snow has stopped and the sun comes out, the air is crisp and clear with strong light bouncing around the landscape. If the air is extremely cold, ice crystals in the air, not quite visible to the human eye, help reflect the light.

Strong light on snow tends to be yellow-white, and shadows on a sunny day are blue, reflecting the sky above. Light may bounce from the snow to undersides of tree branches or foliage, or reflect warm light onto adjacent snow banks. Because it's unpredictable, it takes close and careful observation to determine exactly what the effects of light are on a snowy day.

When the sky is mostly overcast, the color of light on snow tends to be more gray. The vibrant yellows and deep blues characteristic of clear skies are more muted, even if there are occasional bits of blue. Shadows may be warmer, incorporating pinks and lavenders, and while the areas of snow not in shadow are brighter, they are still a gray-white rather than a yellow-white. Moreover, aerial perspective may be even more pronounced, with trees or hills just barely into the midground having a blue or blue-gray cast.

Freshly Fallen - Kim Lordier
Pastel on Belgian mist Wallis sanded pastel paper - 20" × 16" (51cm × 41cm)

PAINTING SNOW ON A CLOUDY DAY
The thin, misty clouds are a wonderful combination of yellows, pinks, grays and lavenders, indicating the bouncing of light in the cold air.

THE EFFECTS OF SNOW ON AERIAL PERSPECTIVE
The background trees have grayed and cooled despite the short physical distance from the foreground trees, probably as a result of light reflecting from the snow.

Sierra Sparkle II
Kim Lordier
Pastel on UArt sanded pastel paper
27" × 39" (69cm × 99cm)

Illustrating Aerial Perspective

Even though light may fall as evenly on objects in the distance as it does on those in the foreground, aerial perspective changes the appearance of these objects. Distance alone can alter color and value; other factors such as atmospheric haze, humidity, dust and pollution can change the color and clarity of the light itself.

To begin to understand the effects of how aerial perspective helps describe distance, look at this simple scene with mountains in the background, a group of trees in the middle distance and a field in the foreground.

Materials

SURFACE
16" × 20" (41cm × 51cm) Belgian mist Wallis sanded pastel paper

PASTELS
Distant plane: cooler lighter green, middle-light warm green

Foreground: bright orange, darker middle-value greenish brown, green, lighter value green, lighter value orange, orange, rust, slightly cooler green, warm middle-value green, yellow

Highlights on trees: dark warm greens, golds

Hills: blue, blue-green, darker green, darker warmer blue-green, darker warmer purple, lighter green, middle-light cool green, middle-light purple-blue, middle-value blue, middle-value slightly warm purple, middle-value blue-green

Sketch: blue, dark brown, dark-value eggplant purple, middle-value gray, purple

Sky: cool blue, cool purple, light-value warm yellow, warm purple

Trees: dark indigo blue, dark purple, very dark green

OTHER
No. 10 Filbert, Turpenoid

REFERENCE PHOTO
As is often the case, the values and colors are not accurate in this reference photo. There is very little color in the sky, and the values of the right-hand trees and hills appear to be very similar. In the final painting, the artist has moved the mountains back and made them a little smaller, increased the amount of foreground, and made significant changes to the color, utilizing aerial perspective to give the viewer a feeling of distance and space.

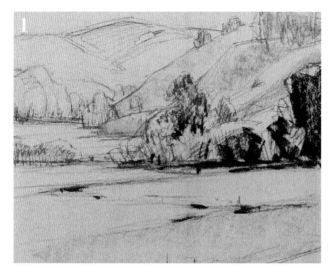

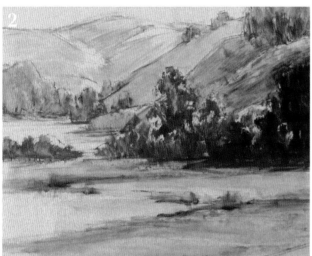

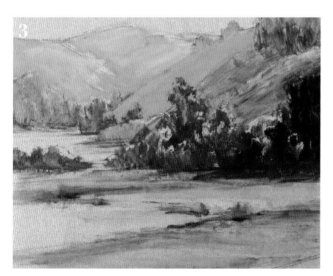

1 Complete the Sketch

Sketch your composition using a dark brown, blue or purple hard pastel. Apply color with a light touch, organizing the shapes into a pleasing design. Use the reference photo as a starting point, making changes to support the concept of your painting.

When the basic shapes are there, suggest the darkest shapes by pressing firmly with your eggplant purple soft pastel and middle-value gray hard pastel. Press less firmly for the midground shapes. There is no need to fill the background shapes with pigment; rather, lightly drag the eggplant purple over the areas that represent the darkest shapes.

2 Lay In the Underpainting

Using your no. 10 Filbert loaded with Turpenoid, fill in the lightest values, beginning with the background. Proceed to the middle-value shapes and the darker shapes. There is no need to fill in details; just allow the brush to dance in your fingers. Have fun, and don't be afraid of drips. The underpainting should represent strong design and good, solid values. Try to keep the values simplified to three or four shades. Allow the surface to dry before proceeding.

3 Color the Distant Hills

Choose a middle-light purple-blue to establish the distant hills. Remember that the hills will progressively get darker as they come forward, so select a value that is closer in relationship to the sky value than the foreground hills and trees. Once this value is set, relate all the subsequent colors and values to this initial color choice, selecting lighter greens and blue-green for the more distant and midground hills, and moving to darker values of blue-green, purple and greens for the closer hills.

4 Develop the Hills and Color the Shrubs

Select a darker and slightly warmer purple for the closest hillside, then layer this with a blue-green of the same value. Make sure the value of this hillside is lighter than the dark shapes of the trees in the foreground but darker than the background hills.

Select a warm yellow, a warm and cool purple, and a cool blue for your lightest values in the sky area, graduating from yellow in the upper right-hand corner to a slightly dark purple in the top left-hand corner. Keep the edges soft where the hills meet the sky to suggest distance.

Bring in your darkest values for the foreground trees and bushes. Keep the marks light in this area to create beautiful transparent passages in the darks, and allow areas of the underpainting to show through. Select a very dark green soft pastel to accent these darks, and add dark indigo blue and purple to create visual interest.

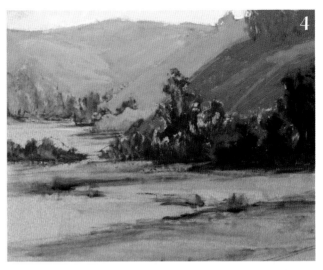

5 Lay in the Foreground

Select a slightly darker middle-value greenish brown. Lay the pastel on its side and lightly drag it across the foreground. Do not press hard at this stage; you're simply laying a foundation for the lighter, more intense colors.

Then, using a warm middle-value green, fill in more of the tooth of the paper, glazing over the greenish brown color. Choose a similar value green (only slightly cooler) to glaze over the midground. Pull traces of this color into the background. Select a lighter and cooler value green to shade the foreground plane.

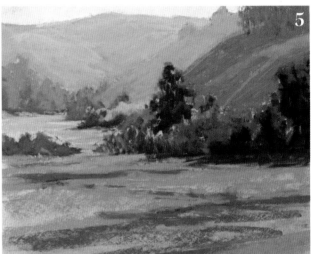

6 Refine Value Transitions

Now that the painting is taking shape, all areas should have a color and value assigned. Take a moment to judge each shape and its respective value. Continue to lighten the background so that it will recede. Keep the highlighted sides of the trees and the edge of the hillsides in close value relationship. For example, the highlight on the dark tree mass toward the center of the painting should not have a sky value used as the highlight color.

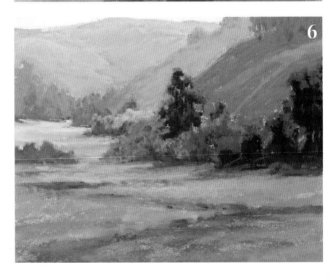

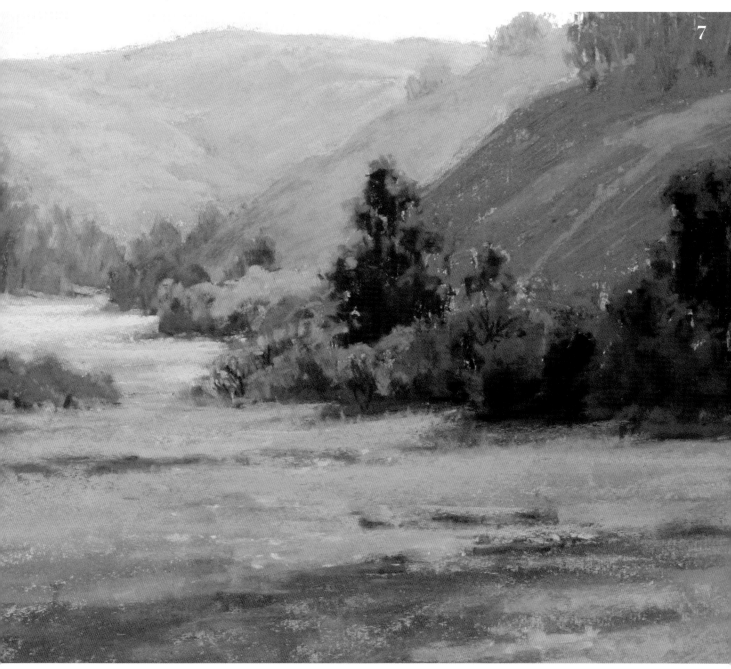

Half Moon Bay Spring - Kim Lordier
Pastel on Belgian mist Wallis sanded pastel paper - 16" × 20" (41cm × 51cm)

7 Add Finishing Touches

Feel free to push the concept of warmer colors in the foreground and cooler colors in the background. Select warmer colors such as bright orange and yellow to add detail or color notes in the foreground. More intense, warmer greens can be scumbled over the original layer of color to create interest. Refine shapes, paying attention to where each shape meets another shape. Utilize less detail and softer edges as you move backward in the painting.

Creating Aerial Perspective at High Altitudes

High altitudes present a unique challenge in portraying aerial perspective. The thin, often dry air challenges the rule that objects become cooler in temperature and lighter in value with softer edges as they recede into the distance. If we paint what we see, we set up conflicts that may confuse the viewer.

When you hang a painting, you don't hang the reference photo beside it to prove your painting looks the same. To create realistic paintings, apply the rules of aerial perspective to tell the viewer what's close and what's distant, even though those effects are not visible in the photo or, in fact, life.

Materials

SURFACE
16" × 16" (41cm × 41cm) white Richeson premium pastel surface on Gatorfoam

PASTELS
Mountains: dark blue, dark blue-green, light blue-gray, middle-value blue-gray, very light blue

Sky: middle-value cerulean blue, very light gray-blue, very light yellow-white

Snow: blue-white, darker blue, lavender, light blue-gray, pink, very light blue

Trees, willows and grasses: beige-brown, brown, blue, blue-gray, dark black-green, dark red, dark-value brown, green-brown, gray-brown, gray-green, lavender, lavender-gray, light blue-gray, light gray, magenta, middle-dark beige, middle-value gray, purple-gray, red-orange, very light pink, yellow-green

Water: blue-purple, dark blue, cerulean blue, very light turquoise blue

Underpainting: beige-brown, black-green, blue, blue-green, brown, cerulean blue, dark blue, dark blue-gray, light blue, light blue-gray, magenta-pink, middle-value blue, middle-value blue-gray, middle-value cerulean blue, middle-dark blue, pinkish brown, pink-white, purple-gray, red, reddish gray, very light blue, yellow ochre

PASTEL PENCILS
Sketch: middle-value blue

Trees: brown-black, middle-value orange, middle-value warm gray, pale gray, white

OTHER
No. 10 Filbert hog hair bristle (or a flat hog hair bristle), Turpenoid

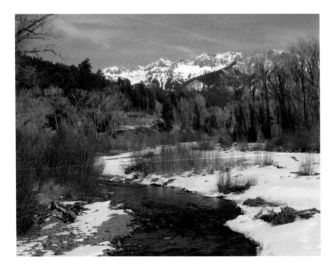

REFERENCE PHOTO
Cropping the photo to a square format will remove some foliage from each side, which does not add to the composition. The river leads the eye to the distant mountains, and revising the composition will emphasize that visual direction. On the right-hand side, the warm color of the cropped willows can be picked up for the clump of willows near the water, bringing this area forward in the picture plane.

1

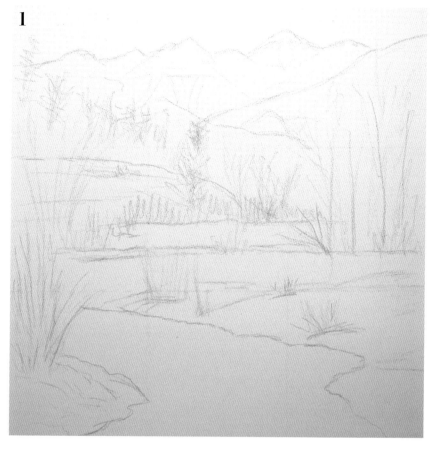

Complete the Sketch
Using a middle-value blue pastel pencil, sketch the composition onto the surface. Simplify the foliage, particularly the willows in the foreground.

Create the Underpainting
Block in large areas of color fairly close to what you want in the final painting. Use a middle-value cerulean blue for the sky; don't worry about the clouds at this stage. In order to create a feeling of distance, block in the distant mountains with a light to middle-value blue-gray. Don't worry about the small shapes of snow, and don't block in the thin, wispy tree branches on the right—those will come later. Lay in the darkest darks with dark blues, black-green for the dark trees, and brown. Block in the midground hillside with yellow ochre and the bushes with several values of pinks, reddish gray and red. The more distant snow masses should be blocked in with a light blue and the foreground snow with a pink-white. Lay in the color of the water with a cerulean blue.

Once you have all the colors in place, wash each color with Turpenoid, being careful to keep colors clean and separate.

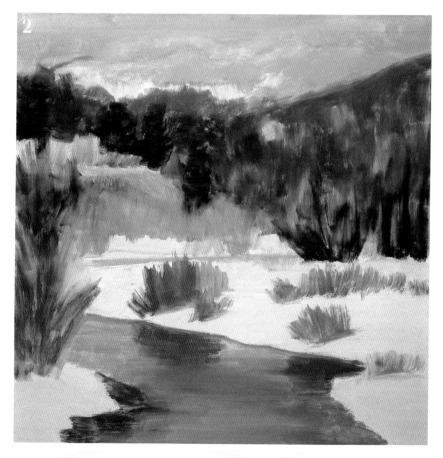

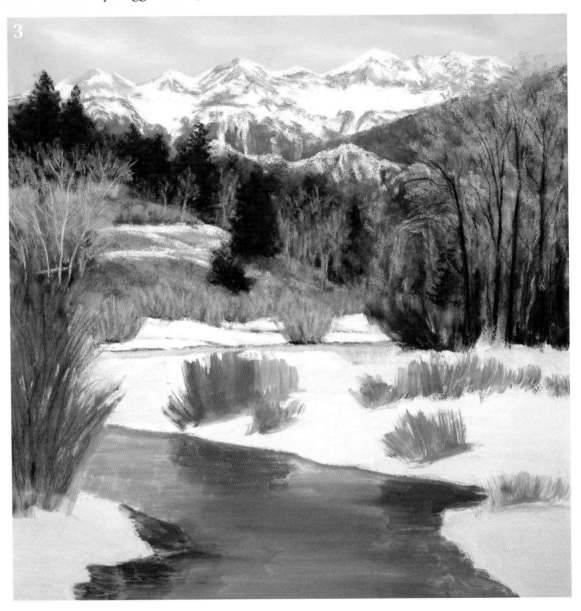

3 Paint the Distance and Midground

Once the underpainting is dry, repaint the sky with a slightly lighter value blue, and paint the clouds with a light gray-blue. Paint the distant mountains, using a very light blue for the snow and a light blue-gray for the land and rocks peeking through. As you move down the mountain range, use a little darker blue for the shadowed area that is not covered by snow and a blue-gray that's a little darker still for the angled mountain slope on the right. Lay in the midground trees and hillside, using pastel pencils in brown-black, middle-value gray and pale gray for the bare trees and the thin white trunks of the aspen. Holding the pastels on the side, use a light beige-brown and light gray to skim a little pastel on the surface to indicate the tiny, wispy branches on the bare aspen trees. Paint the dark fir trees with blue-gray, green-brown and dark black-green.

4 Add Finishing Touches

Paint the snow, paying attention to the darker edges where it meets the water. Use blue-white for the more distant snow so that the cool color will help it recede; use very light values of lavender and pink for the closer snow masses and a darker blue for those edges. Paint the willows in the center left and far left with warmer colors—dark red, red-orange and magenta, as well as warm browns—so that the warm colors will help bring them forward. Paint the reflections of the center red willow with the same colors and smudge it a little, then skim a little cerulean blue ripple over it here and there. Paint the water with dark blue, cerulean blue and blue-purple. Finally, finish the small, brushy willows on the right bank, keeping their colors a little more neutral—using lavender-gray and gray-brown—so as to not distract from the focal point.

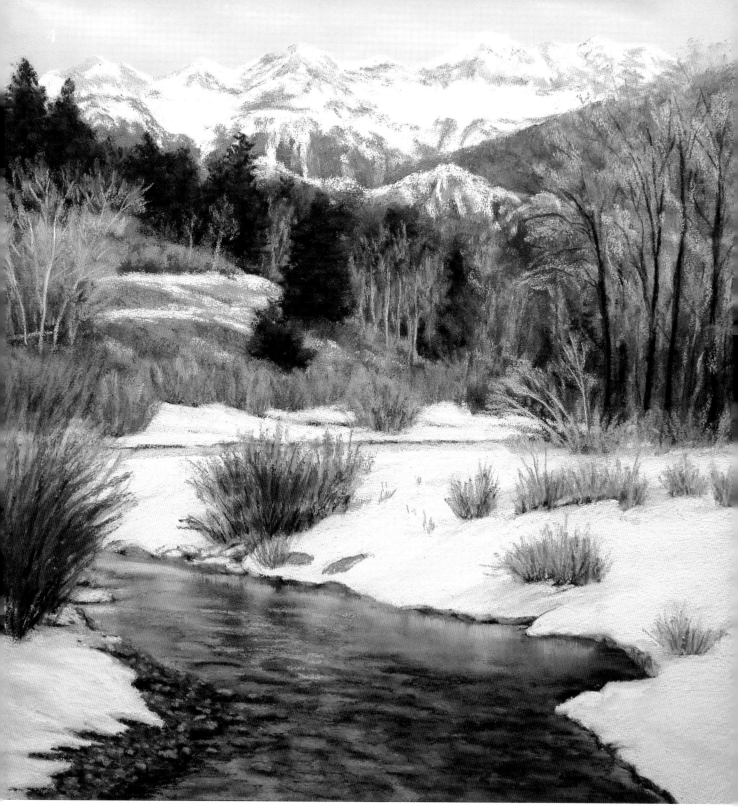

Winter Palette - Maggie Price
Pastel on white Richeson premium pastel surface - 16" × 16" (41cm × 41cm)

Painting Light and Shadow in Snow

As children, when we first learn to color, we see the world simply, assigning colors to objects primarily based on what others tell us. We're told the sky is blue, clouds are white, tree trunks are brown, and grass is green. As we become artists, we have to unlearn these simplistic notions of color and begin viewing the world without prejudgment.

Though many artists are able to debunk these color myths easily, the hardest lesson to learn may be that snow isn't really white after all. When we look out the window and see white everywhere, it's a natural instinct to reach for that white stick of pastel. But snow, like water, reflects, bouncing color between its crystals and flakes creating a rainbow. To paint snow effectively, you must learn to observe that rainbow and find the myriad colors.

Materials

SURFACE
36" × 24" (91cm × 61cm) UArt sanded pastel paper

PASTELS
Foreground: middle-value blue

Houses: blue-gray, burgundy red, middle-value gray, red-brown, teal

Midground: cobalt blue, middle-value warm yellow, warm yellow-white

Mountains: cobalt blue, dark gray-green, dark teal, gray-green, middle-value red ochre, middle-value orange

Road: cobalt blue with turquoise

Sketch: light gray

Sky: light and middle-values of blue, gray-purple, peach, pink, purple, turquoise

Snow: dark teal blue, light blue-purple, light cobalt blue, light peach, middle-value cobalt, middle-value blue-purple, middle-value peach, middle-value teal, warmer blue with a touch of turquoise, turquoise with a bit more purple, white

Trees: cobalt blue with turquoise, dark blue, dark brown, dark gray-green, dark green, dark navy, dark purple, dark teal, middle-value red ochre, middle-value warm gray-green, warmer blue with a touch of turquoise, warm red ochre

Underpainting: blue, blue-gray, bright orange, brown-gray, dark brown-orange, dark cool red, dark purple, gray-purple, light peach, light purple, middle-value gray, middle-value gray-purple, purple, red-brown, red-purple, teal, yellow ochre

Willow marsh: lighter ochre, orange, red ochre

OTHER
1-inch (25mm) flat synthetic brush (old or well worn), clean container for rubbing alcohol, rubbing alcohol

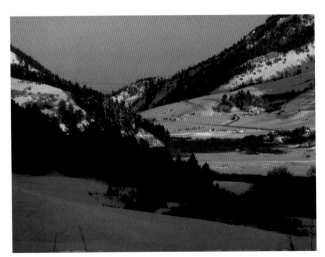

REFERENCE PHOTO
Cropping or zooming in can sometimes be the most important decision involved in creating an effective composition. In this case, cropping the photo in from the sides to make it vertical in format will emphasize the impression of the canyon and mountains. This change will also enhance the diagonal patterns of darkness and light. Zooming in on the subject will shift the focus toward the light coming over the mountain at sunrise.

 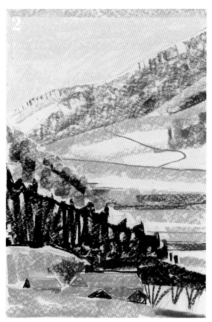 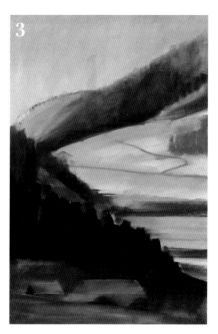

1 Complete the Sketch

Crop your reference photo to the same proportions as your painting surface. Divide both the photo and your paper into thirds or fourths. Using a hard light gray pastel, lightly draw in the big shapes of the composition, making sure you place them in the correct positions by referring to the grid lines on both the photo and the surface. Don't put in a lot of details in this phase. The simple shapes are enough to help you evaluate your composition.

2 Lay In the Underpainting

Lay in the sky with light peach, light purple and middle-value gray-purple. In the background and midground, use middle-value gray-purple, yellow ochre, brown-gray, and red-purple, along with a bright orange and a dark brown-orange. Underpaint the foreground with a middle-value gray, gray-purple, blue-gray, blue, purple, teal and red-brown, along with a dark purple and a dark cool red.

3 Wash With Alcohol

Using your 1-inch (25mm) flat, go over each area of color with rubbing alcohol. Start with the lightest value areas, washing with swift, sure strokes. Don't worry about the marks the brush makes; they will be covered up later. If there are any strong marks that bother you, blend them away by using a wetter brush.

To avoid creating drips, move the alcohol around quickly with your brush. Finish with the darkest colors, making sure every area has been covered. You may choose to go over the entire painting one more time with alcohol to soften edges or cover areas you might have missed. While the alcohol is drying, evaluate your composition and make any necessary changes.

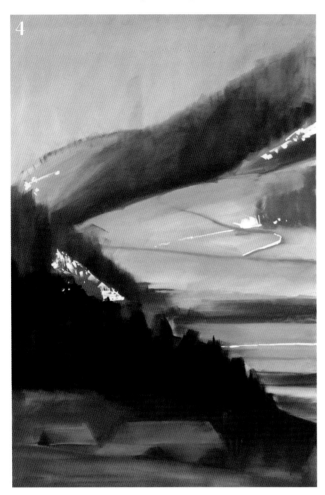

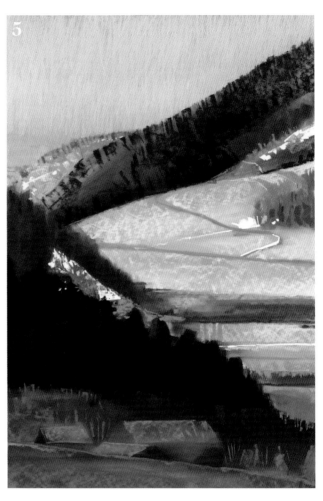

4 Establish Value Extremes

Locate the darkest dark—in this case, the group of pine trees that runs diagonally across the lower third of the painting. It may look black, but it's actually full of lively color. Lay in this dark using a dark teal or a dark blue, purple or green.

Next, establish the lightest light values located on the mountainsides and snowbanks facing the sun, and block in touches of white in these areas.

5 Begin Painting the Sky, Foreground and Trees

Paint the sky using light and middle values of blue, turquoise, peach, gray-purple, purple and pink. Starting with the light values at the bottom of the sky, begin overlapping colors on top of each other, slowly moving into the middle-light values as you work to the top of the painting.

For the foreground, choose a middle-value blue that is the same value as the purple underpainting. Place a mark of blue on the purple and step back to determine if it's the correct value and hue. Then place touches of the blue throughout to tie the composition together.

To double-check that your sky is the correct value, lay in some dark value teal to indicate the pines on the ridge-line. If the pines appear to be the correct color against the sky and the blue color notes placed throughout, then your values are correct.

6 Color the Snow and Develop the Foreground Elements

The more perpendicular a surface is to the sunlight, the brighter and warmer the light appears to be. As surfaces angle away from the sun, they start to reflect what is above—in this case, the blue sky.

In the midground, the terrain varies from flat to hilly. The flat surfaces in shadow reflect more of the sky, so leave more of the purple underpainting showing through, then scumble on a similar value cobalt blue. Where the surface turns toward the rising sun, lay down a middle-value warm yellow over the purple underpainting, then lighten it a bit with a warm yellow-white.

Now work on the color of the snow in the shadow areas of the background mountains. Since they are in the background, the colors are affected by atmosphere, which grays them a bit and lessens the value contrast. Lay in a middle-value teal, then modify it with a middle-value blue-purple laid on top. Don't cover up all the underpainting; you want bits of purple to peek through between trees and snow.

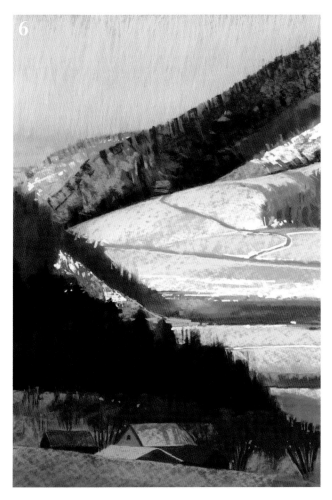

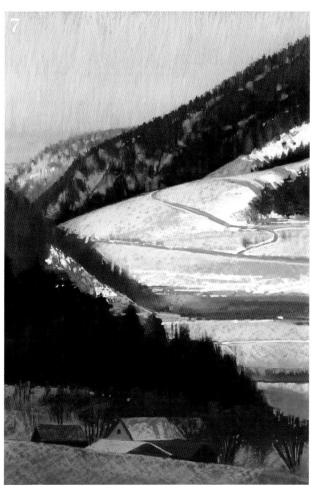

Shift your attention to the houses in the foreground. Since this area is in deep shadow, work with middle to dark values. Paint the snow-covered roofs using the same blue used for the snow on the ground, making sure to keep the angles of the roofs parallel to each other. Paint the buildings using a combination of middle-value gray, blue-gray, red-brown, teal and burgundy red. Keep things simple. Try to apply the pastel using the sides of the sticks, skimming the color on. If you need a straight edge, use the edge of a square pastel, or flatten the side of a round one by rubbing it on sandpaper until you create an edge. It's easier to create a straight line with the side of a pastel than to draw a line with the point.

7 Finalize the Background Mountains
Use a middle-value peach to suggest the sunlit snow on the farthest mountain and a middle-value warm gray-green for the trees. Minimize detail since these mountains are receding into the background.

The mountain range in front is in shadow and closer to the viewer, so use darker, cooler colors like dark teal, gray-green and cobalt blue. Again, minimize detail to indicate distance, blurring the trees together as you apply marks.

Indicate snow using a slightly lighter cobalt blue layered with a warmer blue with a touch of turquoise in it. Where the sun is starting to touch the trees on this mountain, use a middle-value red ochre, dragging it over the trees and allowing some of the cooler tree color to show through. Use the same colors to finish the two small groupings of trees on the right. Use the same cobalt blue with turquoise for the snow shadows in the trees and for the shadow of the road. The road itself is the underpainting showing through; don't put any more color on top of it.

8 Refine the Midground

Finish the sunlit mountain rising in the left midground by laying in a dark gray-green and then scumble over it with a middle-value red ochre. Top this off with a middle-value orange. Use red ochre and orange as a base for the willow marsh running horizontally across the painting, with a lighter ochre for highlights.

Paint the snow on the mountain to the left using a light peach color with touches of middle-value peach for the undergrowth.

Paint the snow fields below the willow marsh with light blue-purple in the sunlit areas, and middle-value cobalt and turquoise with a bit more purple in the shadowed areas above.

The extremely dark treeline is not black but a mix of dark green, dark teal and dark navy. Use a dark gray-green (one value step lighter) to define the tops of the trees and the branches.

9 Add Finishing Touches

Paint the area under the foreground trees using dark teal blue to indicate the snow in deep shadow. Slightly darken the buildings so they become less of a focus, allowing your eye to move easily toward the focal point. Develop the tree trunks around the buildings using dark brown, then lighten the crowns of the trees with a warm red ochre.

Complete the angled snow bank. Give the impression of depth, graduating the snow banks so they appear darker at the bottom and lighter at the top as they catch some of the reflected light from the sunrise. Layer middle-value cobalt blue and turquoise over the purple underpainting, leaving some of it showing through in the darker areas to indicate shadows.

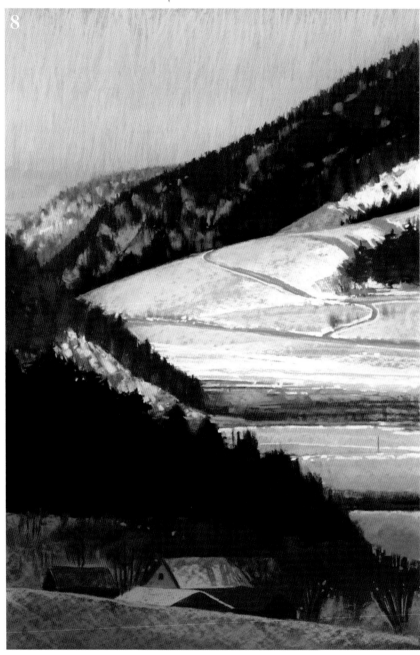

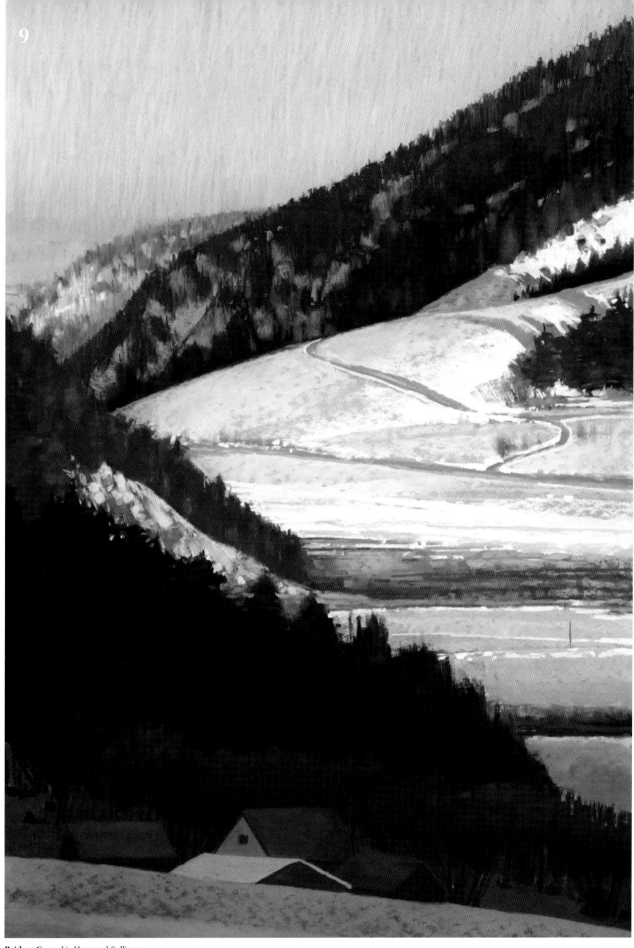

Bridger Gap - Liz Haywood-Sullivan
Pastel on UArt sanded pastel paper - 36"× 24" (91cm × 61cm)

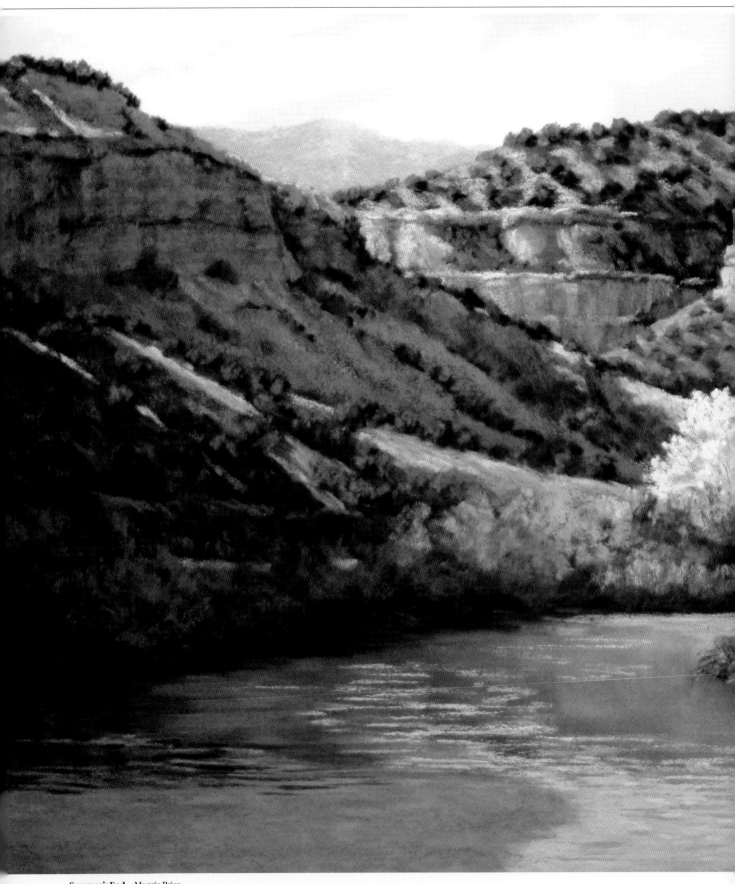

Summer's End - Maggie Price
Pastel on Richeson premium pastel surface - 18" × 24" (46cm × 61cm)

Creating Realistic Shadows

Light and shadow are forever paired, the yin and yang of describing form. Without light, shadow is a meaningless void; without shadow, light is only a bright glare. Learning to paint shadows well can enhance the light-filled areas in your paintings, making them as dramatic or as subtle as you choose.

Shadows can be deep and mysterious, luring the viewer into the painting and encouraging him or her to imagine what they contain. They can also be gentle, subtle shades moving away from the light, creating restful and tranquil spaces.

No matter what your chosen subject is, shadows are an undeniably important component in creating accurate paintings. In this chapter, we'll explore the various ways you can utilize shadow to make your paintings stronger.

Describing Form With Shadow

Hills and valleys, craggy cliffs and mountains, winding roads and narrow trails—no matter the subject, its form is described by light and shadow.

Light is less effective at describing form than shadow. When light begins to move into halftone areas—which are part-shadow—form begins to take shape, only to be truly explained when light decreases gradually into deeper and deeper shadow.

But shadows don't have to be dramatic to reveal the form of an object; subtle, soft shadows can also describe form. For example, the curve of a cheek can be explained with a subtle gradation away from light into shadow. Likewise, the soft falling-away of a gentle hillside can be described by the gradual removal of light.

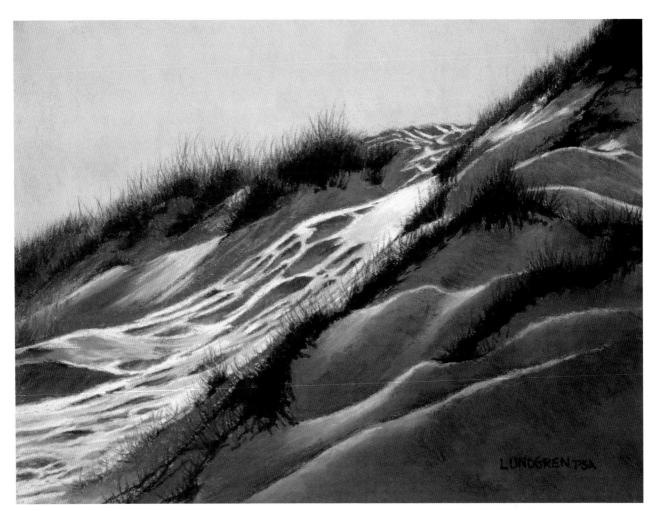

INDICATING SHAPES WITH SHADOW
The reference photo for this painting was taken in the Florida Panhandle, a place known for its white, sugar-sand beaches and dunes. The shadows cast by the early morning sun emphasize the wind-shaped ridges and depressions in the white sand dune. The value of the shadows in the sand is darker than the value of the sand in sunlight. These value changes clearly indicate the shape of the small rises and depressions in the sand.

Sun Sculptured Dune - Richard Lundgren
Pastel on Richeson premium pastel surface
12" × 16" (30cm × 41cm)

Employing Shadows to Define Pathways

When you're painting scenes with either roads or paths, experiment with the shapes of shadows to see how you can define edges and planes. If you're altering your composition by inserting a more interesting dirt road rather than a paved surface, remember how shadows can help you make this look realistic.

Dirt Roads

Roads, particularly dirt roads, can easily blend into their surroundings, but cast shadows will define their edges and indicate bumps or uneven places. Ruts on the edges will have a shadowed side, and foliage creeping onto the edge of the road will cast shadows as well.

Paths or Trails

Paths or trails can also be hard to define, but the shadows created at their edges indicate their size and shape. Lost edges merge into shadows, while crisply defined shapes and sharp-edged shadows create contrast and further definition.

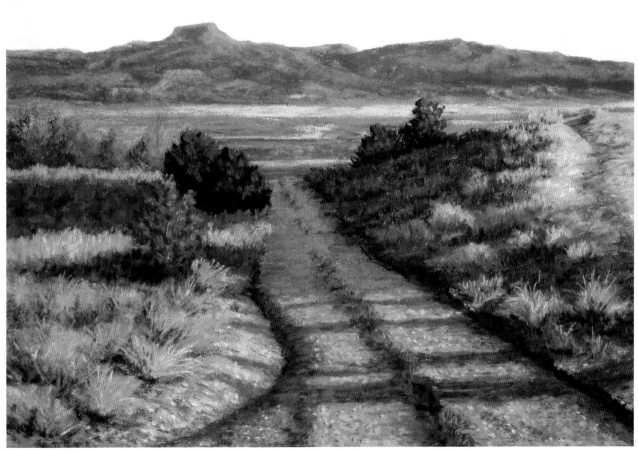

ENHANCING YOUR PAINTING WITH PROPER SHADOW PLACEMENT
Long afternoon shadows from unseen trees on the right are cast across the road, providing extra dimension. Shadows define the angle of the hillside and the subtle path winding over the rise on the right. Equally important, shadows work to separate clumps of the desert foliage, helping the juniper and piñon bushes stand out among the grasses.

Ghost Ranch Road - Maggie Price
Pastel on white Richeson premium pastel surface
16" × 20" (41cm × 51cm)

Determining the Color of Shadows

So what color are shadows anyway? There is no absolute answer to this question, but a good place to start is to examine the objects that fall in shadow. The color of an object in shadow is the same as it is in light, only darker. After all, a shadow is created simply by blocking the light source. Exactly how much darker the shadow is than the light area depends on many factors, including the angle of the light source and the proximity of the shadow to the object that casts it. In order to paint lifelike shadows, you'll need to observe them carefully.

On a bright day when the sky is clear and blue, shadows often pick up a bit of reflected blue from the sky. Be careful not to overdo the blue though, or your shadows won't look realistic. Using several colors of similar value in shadows will keep them lively.

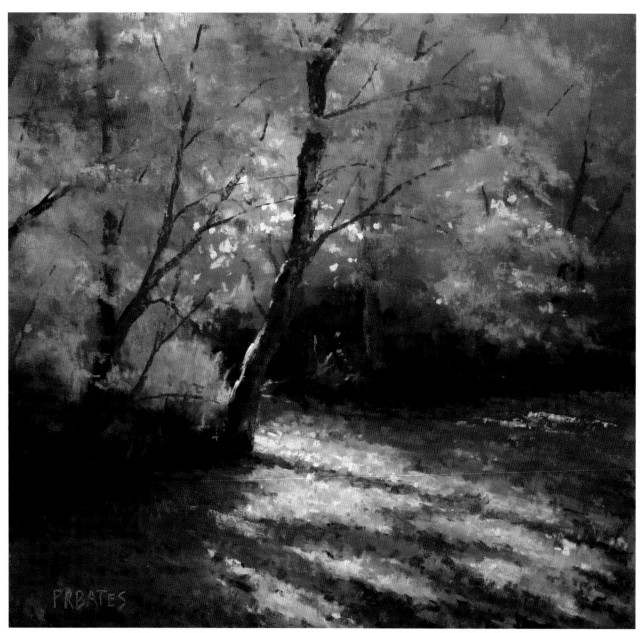

LIVELY COLOR MAKES SHADOWS INTERESTING
The road or leaf-strewn flat plane in the foreground consists primarily of shades of beige and orange. The shadowed areas are painted in oranges, browns and subtle touches of blue. The shadow color is strongest closest to the light and becomes more muted as it moves away from the light source. The shadows in the foliage are darker foliage colors mixed with blues.

Touch of Light - Phil Bates
Pastel on Wallis sanded pastel paper
16" × 16" (41cm × 41cm)

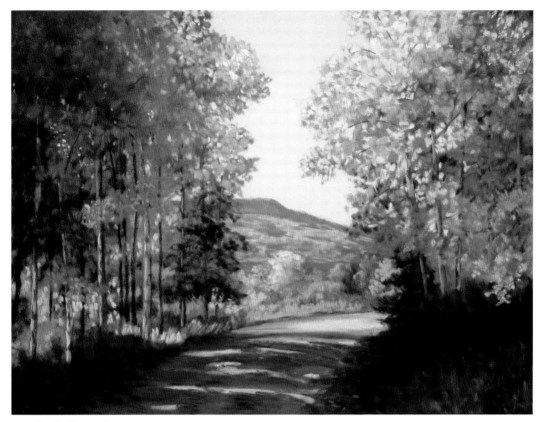

Aspen Road - Maggie Price
Pastel on Pastelmat - 9" × 12" (23cm × 30cm)

AN EXCEPTION TO THE RULE

Shadows aren't always blue or purple, but the color of a shadow is determined by the color of the object onto which it is cast. The color of the road is a lavender-gray, which gets lighter in value as it's touched by strong sunlight. Where the sun blocks the light and creates shadows crossing the road, the lavender-gray becomes darker and picks up a little blue from the reflection of the sky. The color of the shadow changes where it crosses foliage on the sides of the road, becoming darker values of the colors of the grasses or bushes.

Shadow Myths Uncovered

Here are several of the most common misconceptions when it comes to the color of shadows:

- **Shadows are always blue or purple.** Though there may be components of these colors within a shadow, generally the only time you will see shadows that are truly blue or purple is in the snow or along the side of a white surface. Observe the shadows cast across a meadow or field of green grass—there may be blue or purple components, but the predominant color is still green. The exceptions to this rule arise when the color of the object contains a significant amount of red. A pinkish adobe wall may have purple shadows, and a red dirt road will undoubtedly have shadows tending toward purple on a sunny day when the reflected blue is added to the red of the dirt. Careful observation will lead you to the right color.

- **Shadows are not darker than the value of the object that casts them.** This is easily proved false when you look at a shadow cast by a white building. A shadow is cast because a solid object blocks the light; the color of the object is irrelevant.

- **A cast shadow will contain the complement of the color of the object casting the shadow.** This theory may have roots in the fact that when you focus on a color for some minutes then look away and close your eyes, you will see that color's complement. Try it. For example, focus on a bright red object, then look away and close your eyes. You'll probably see the same shape, only green. However, this has nothing to do with shadows. The shadow may contain a little reflected light, but the reflected light will be the color of the object, not its complement.

Creating Colorful and Rich Shadows

When observing shadows in nature, take time to study the colors you see. Even in the deepest shadows, you'll often see rich colors that correspond with the colors you see in the sunlight. For instance, you might expect masses of green foliage to have shadows of darker green. However, further study may reveal that there are more colors than just green in the sunlit areas, and thus more colors than dark green in the shadow areas.

Look for rich browns, reds, blues and purples, and try to observe color rather than assume you know what color it will be. The more you study shadows, the more you will be amazed by their rich complexity and variety of color.

EDITED REFERENCE PHOTO
The patterns of shadows and fallen leaves in the original photo provided lots of potential for exploring color and value. However, the position of the focal point and the definition of the foliage above the path was a bit boring.

To remedy these issues, artist Phil Bates used a software program called Adobe Photoshop. First he cropped the photo to a square format, moving the area of interest—the path where it disappears behind the bushes—into the upper right quadrant. Then he made compositional changes to the foliage to add interest. The photo above is the result of these edits.

If you're uncomfortable using a computer to make such changes, you can just sketch how you want the composition to appear in your final painting.

Materials

SURFACE
18" × 18" (46cm × 46cm) UArt premium sanded pastel paper, 500 grit, dry mounted on 4-ply museum board with ½-inch (12mm) border

22″ × 22″ (56cm × 56cm) black Gator board

PASTELS
Branches: middle-value and dark gray, grayish violet, grayish brown

Foliage: cream, grayish red, grayish red-violet, greenish yellow, lavender-gray, middle-value olive green, middle-to-dark grays, middle-to-dark orange, middle-to-dark red, middle-value orange, pale grayish orange, pale orange, pale yellow, red, reddish orange, reddish pink, rust, violet-gray, yellow, yellow-green, yellow ochre, yellow-orange

Highlights: bright orange, brilliant yellow, orange-white, pale orange, pale yellow, reddish pink, warm white, white, yellow-green, yellow ochre, yellow-white

Road: lightest gray, gray-violet, light warm grays, light yellow

Shadows: bluish gray, bluish violet, cooler violet, dark bluish violet, dark gray, dark olive green, dark orange, dark red, darkest gray-violet, darkest violet, gray, middle-value dark gray, middle-value dark grayish violet, middle and dark lavender-gray, very dark eggplant, warmer dull greens

Sky: bluish violet, very pale cool blue

WATERCOLORS
Underpainting: Cadmium Yellow Light, Cadmium Yellow-Orange, Cadmium Red-Orange, Payne's Gray, Sap Green, Carbazole Violet, Cobalt Blue

OTHER
½-inch (12mm) fine mop brush, 1-inch (25mm) masking tape, foam pipe insulation, fixative, HB pencil, no. 4 or no. 6 synthetic watercolor brush, paper towels

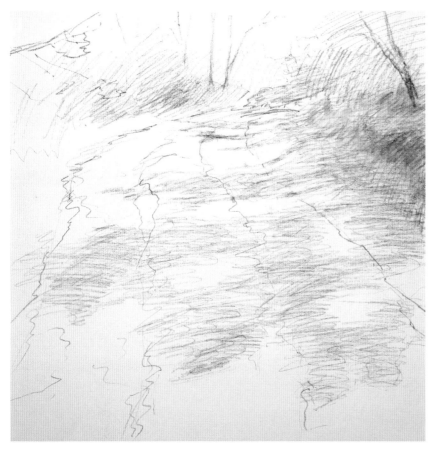

1 Complete the Sketch

It's helpful to do several thumbnail sketches first to lock the composition in your mind, giving you practice and confidence before committing the drawing to a full-sized surface. When you're ready to start on the painting surface, use an HB pencil to sketch the basic outline of shapes, lightly hatching in the darker masses. Put in critical detail where it is needed, but at this stage keep it simple—accurate is better than pretty. In order to preserve any lines you want to see in later stages of the painting, use a light spray of fixative to protect them from the watercolor underpainting.

2 Lay In the Underpainting

Lay in your watercolor base with your watercolor brush, matching the local color and value as close as you can. Use large strokes and work quickly in order to preserve soft edges and big shapes. The final painting will be warm and light, so use lots of yellows and oranges for the highlights and dark violets and Payne's Gray for the shadows. Add cooler notes of green, violet and blue in the distance. Drips and runs can be interesting for some scenes, but distracting for others—decide whether you will allow them or not. Place the painting on a horizontal surface to control watercolor runs and bleeds.

Let your first attempt dry, then add darker masses as needed. When finished, let the watercolor dry completely, then brush off any particles or bristle hair that may be left on the surface.

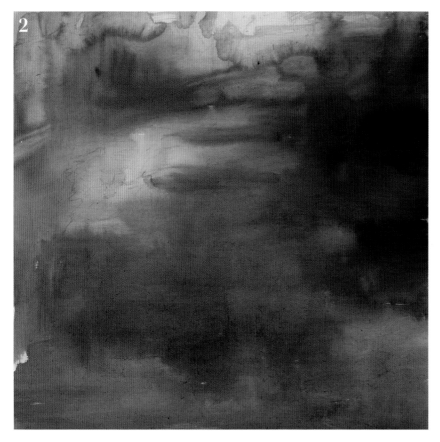

3 Rough In and Scrub Pastel Color

Use an assortment of warm browns, oranges and purples for the dark values, and lighter oranges and yellow for the lighter areas.

Rough in basic shapes with your pastels, correcting the watercolor underpainting and refining the color and value while still leaving some of the underpainting visible. Add some lighter pastel for the road highlights and cooler blue notes for the sky, but reserve your lightest values. Use hard pastels at this stage.

Use a piece of foam pipe insulation to scrub the pastel and push the pigment deep into the grit of the paper, leaving more tooth for subsequent layers of color. Use horizontal movement to help make the path look flat. Start with the lightest values and work toward the darkest. Before proceeding with the darkest tones, wipe the foam piece clean with a paper towel.

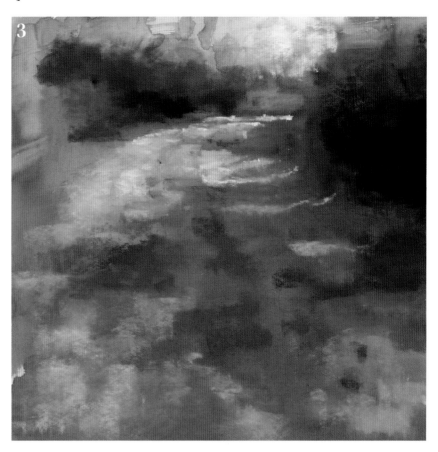

4 Add Smaller Shapes and Soften the Edges

Continue to rough in smaller shapes with hard to medium pastels to create the details. Use a dark gray-violet for the shadows under the bushes on the right side of the painting and a slightly lighter value of gray-violet for the cast shadows on the path.

Finish filling in the lightest values as well. Add light yellow to the left edge of the path and rich reddish tones to the foliage on the right. Then add more touches of your lightest gray-violet to the lit surface of the road.

Use the pipe insulation as needed to soften rough edges and textures. Vertical strokes on the left side of the path will help the yellow grasses take shape.

Start painting patterns of leaves on the path with medium to soft pastels, using pale grayish orange for those leaves in sunlight and a cooler grayish red for those in shadow.

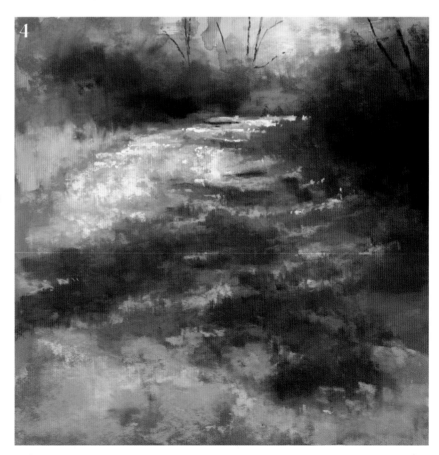

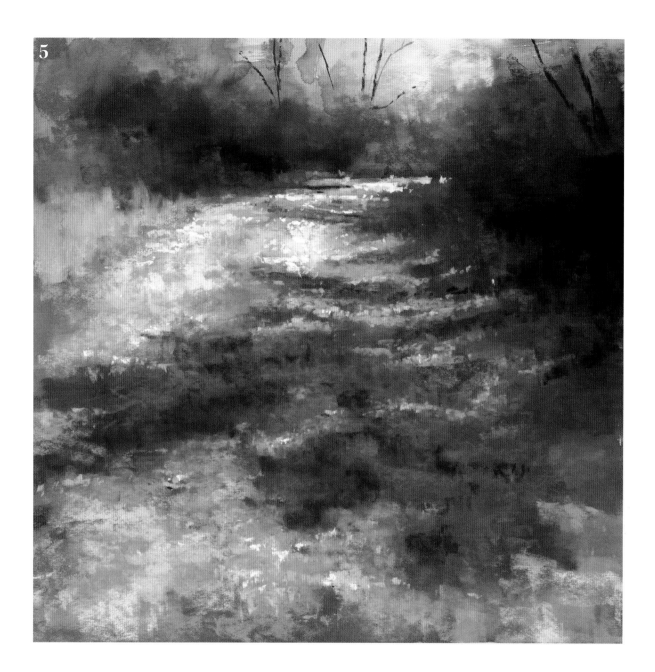

The shadows are soft, so use in-between colors for transitions between highlight and shadow. Allow yourself some fun with warm reds, but keep these marks at a minimum. Lay in the lightest leaves in the distance with pale yellow. Again, don't use your lightest pastels—save some room for detailed highlights that will be added later.

Develop your focal point—the area where the path disappears around the bend—placing marks of high contrast, including a few dots of path that are revealed as it curves behind the foliage. For a few more bright highlights to lead the eye to the focal point, add touches of your softest pastels using warm white, pale yellow, brilliant yellow and pale orange. For the darker leaf shadows on the path, use middle-value dark grays and violet-grays.

5 Begin Refining Light and Shadow Details

Place light and shadow details that will help lead the viewer's eye down the path. Leave some parts of the painting diffused so as not to distract from the area of interest, and begin adding random variations to make the path appear more realistic. In the shadows, add some warmer dull greens, grays and cooler violets to vary the darkness slightly. In the sunlight, make similar variations by adding yellow ochre, reddish pinks and a few notes of bright orange and yellow-green. Make the exposed dirt in the foreground pale gray-violet in the lightest spots, glazing the color to leave a granular dirt-like texture. Vary with a few smaller masses of slightly darker gray-violet, especially in the transition zones. Finally, place more greens in the background foliage of the distant trees.

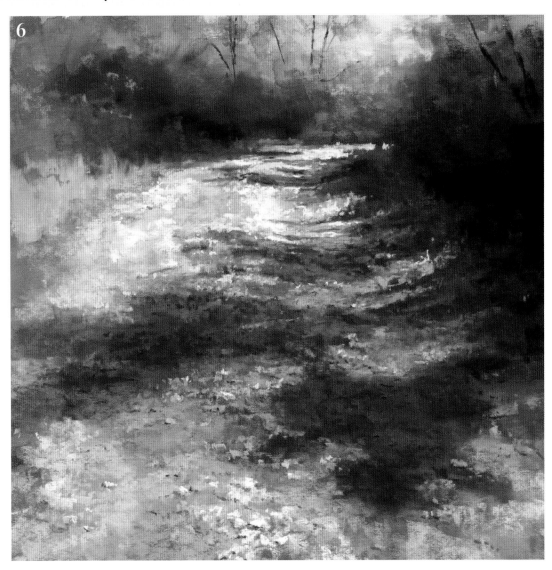

6 Place Highlights and Adjust the Shadows

Add some individual notes of white, yellow-white and orange-white to indicate bright sunlight on those leaves angled to get the most reflection from the sun. To keep it realistic, don't overdo these brightest highlights. Make sure you have some partial shadow/transitional leaf colors that reside between deep shadow and full sunlight.

Add the large shadow in the lower right. The shadow needs to look like it's coming from a tree off the right edge of the painting. First remove some of the existing pastel, using your ½-inch (12mm) mop brush to expose fresh tooth for a new application of color. Then lay in the shadow using middle and dark values of a lavender-gray.

Turn your attention to the leaves on the path. Since they are not just colored spots lying flat on the ground, they need to look like forms that cast shadows. Use a soft middle-value gray-violet to add shadows to some of the leaves in the sunlight. Paint the leaf shadows in the shade using dark lavender-gray, keeping in mind that these leaves have less contrast than those in direct sun.

7 Add Finishing Touches

Add final touches with your softest pastels, including a few more bright highlights and darker leaf shadows on the path. Define the foliage around the center of interest, keeping it in shadow to contrast with the sunlit path. Use soft pastels in middle to middle-value dark grayish reds for this task. Define the foliage a little more on the sides with brilliant notes of yellow, yellow-green, orange and reddish orange. Add a few twigs, branches and light on the distant trees with similar grayish colors used previously on the thicker branches.

Sharply define the foliage on the right and left of the path to suggest that it has a border and to increase the sense of light. Pastels with a sharp point will be helpful at this stage.

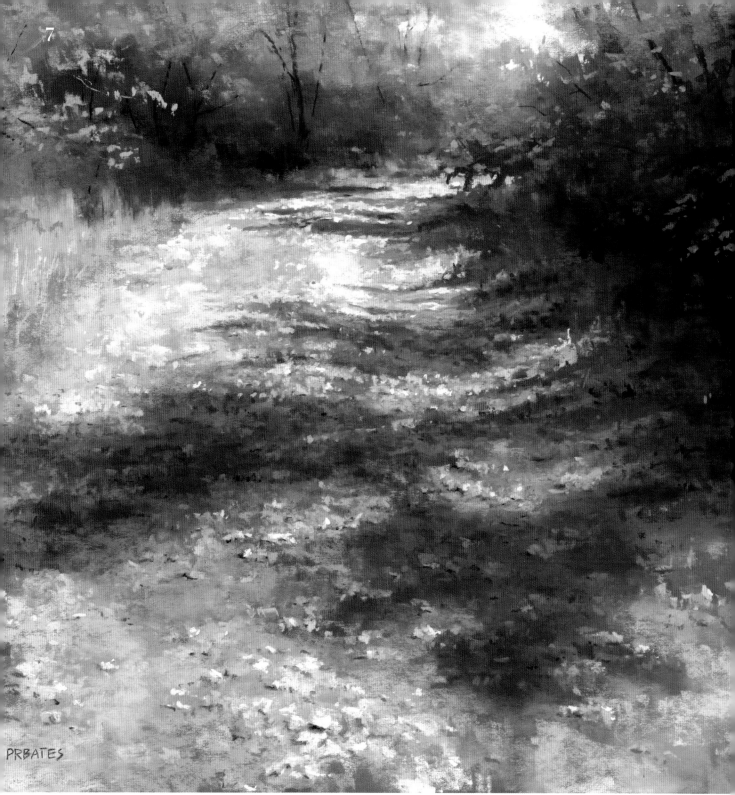

Come This Way - Phil Bates
Pastel on UArt sanded pastel paper - 18" × 18" (46cm × 46cm)

Using Cast Shadows With Sunspots to Describe Form

While cast shadows certainly suggest the shape and form of the objects that cast them, the added presence of sunspots can help the viewer visualize the objects more clearly. This is particularly true if the shadow is coming from an object outside of the picture plane, as is the case with the reference photo below.

Sunspots within cast shadows help to define the nature of the object that cast the shadow. When a shadow is cast by trees or foliage, for instance, the sunspots may follow the edges of branches or define masses of foliage, creating interesting patterns of light within the shadows.

Materials

SURFACE
16" × 16" (41cm × 41cm) UArt sanded pastel paper (500 grade)

PASTELS
Adobe building: blue-gray, dark peach, light peach, middle-value peach, orange, peach, purple, rust, warm yellow ochre

Foliage: blue-gray, burgundy, cobalt blue, cool green, dark purple, dark warm green, light orange, middle-value green, middle-value pink, peach, pink, purple, red, warm green, yellow-green

Low wall: light warm gray-yellow, gray-green, gray, middle-value blue-gray, dark gray

Sketch: light or middle-value gray

Sky and background: dark warm green, cool green, lighter blue, light-value green, middle-value blue, middle-value dark green, middle-value warm green, middle-value yellow-green, turquoise, warm greens

Underpainting: dark purple, light orange, light peach, middle-value orange, warm middle-value purple

Walkway: light warm yellow and purple, middle-value purple and blue-gray, dark gray

Windows and doorway: cobalt blue, dark cobalt blue, darkest purple, middle-value cobalt blue, purple, turquoise

OTHER
½-inch (12mm) synthetic flat brush, rubbing alcohol

REFERENCE PHOTO
Crop the photo to a square format for a more pleasing composition. It's helpful to tape the composition off with white artist's tape (which can be removed without damaging the photo) and mark divisions for easy reference when drawing the subject.

A Note About Cast Shadows

A cast shadow is darkest near the object that casts the shadow and becomes lighter as it move away. If you paint a cast shadow with only one value, it won't "lay down" properly. To solve the problem, use several values, with the darkest value closest to the object casting the shadow, getting progressively lighter as the shadow moves away. The number of values you will need will depend on the length of the shadow.

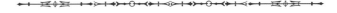

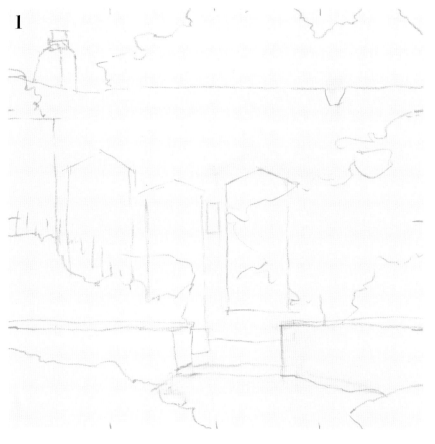

1 Complete the Sketch
Mark divisions on your paper to match those on the photo. This will help you place the big shapes accurately. Use a light or middle-value hard gray pastel, dark enough to see the lines but not too dark to cover up in the final painting.

2 Lay In the Underpainting
It's easier to paint light spots on top of a cast shadow area than to paint a shadow around a light spot, so place shadows in this phase. Use the predominant shadow color when blocking in areas.

On the adobe walls use a warm middle-value purple; for the windows and door use a dark purple; for the background use light orange and light peach; and for the foliage use dark purple in shadow areas, middle-value orange for the middle areas, and light orange and light peach for highlight areas. To unify the composition, use the same middle-value purple from the adobe walls for the horizontal cast shadows on the walkway.

When you place very dark colors next to lighter colors, do not apply the pastel right to the edge of the shape. When you wash it down, dark colors tend to spread. To prevent this, leave a little white space between the darker and lighter colors.

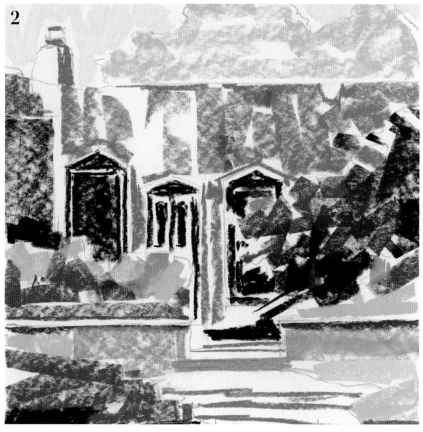

3 **Apply Alcohol Wash**
Using a clean ½-inch (12mm) flat brush dipped in rubbing alcohol, wash down the underpainting. Start with the lightest colors in the sky, and use quick, bold strokes, making sure the alcohol doesn't drip. Follow your lines from step 1, but don't worry about keeping the edges perfect because you can clean them up later.

After all the pastel has been washed down, allow the surface to dry.

4 **Establish the Value Road Map**
After the underpainting is dry, locate the darkest darks and lightest light areas. By placing spots of correct color and value in critical locations, you will give yourself a value and color road map.

Use dark purple—your darkest dark—in the window panes and under the foliage above and behind the wall. The lightest lights are the light warm yellow on the walkway and the light peach drifting down the adobe wall.

When putting light spots on shadow areas, it is important to remember where the light is coming from. On the adobe the light peach spots are being cast diagonally across the wall from upper left to lower right. On the walkway the light warm yellow spots are thin lines running horizontally across the ground. It is very important you draw what you see with cast shadows. If you don't get the shapes correct, then your shadows will be misleading.

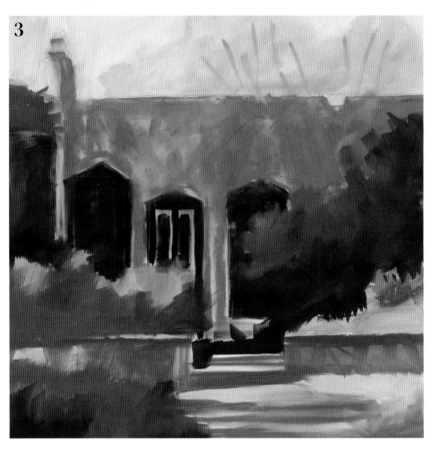

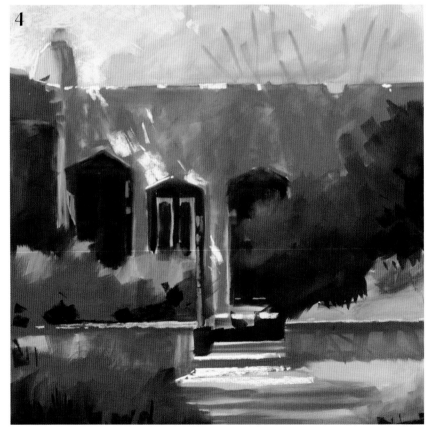

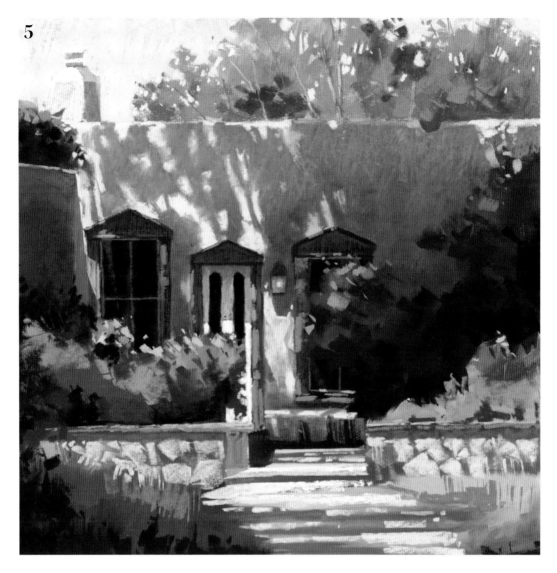

5 Define Forms Using Color

Start developing larger shapes of color. Refer to the road map you created in step 4 to keep your values accurate.

Paint the sky and the background trees using lighter and middle-value blues and greens. Keep the detail to a minimum in the background trees so they don't draw attention.

Scumble warm yellow ochre, rust and dark peach in the shadowed areas on the adobe, making sure your colors are the same value as the underpainting. This warmth creates a vibrant adobe wall and indicates reflected light from the front walkway. Place middle-value cobalt blue and turquoise on the doorway and windows to indicate where the light is hitting the frames. Develop the stone wall in front using the side of a warm gray-yellow pastel to make broad strokes for the stonework.

Start bringing the middle-value greens into the foliage in the midground and foreground. Use warmer greens in the midground and cooler greens in the foreground because this area is in more shadow.

Now you can begin finishing certain areas, starting with the background and moving forward. Complete the trees behind the building using middle-value yellow-greens and warm greens for the sunlit areas, and middle-value dark, cool greens for the shadowed areas. Then add a middle-value blue-gray along the upper edge of the shadows spilling over the wall. This indicates light reflected from the blue sky.

As the sunspots spill down the wall over the windows and door, be careful to connect the light on the adobe wall to the light on the blue frame next to it. Since the focal point is the door, make sure that the marks you make don't distract from it.

In order to keep the painting from becoming too busy, downplay the foliage on the right and allow the upper right of the adobe wall to be lost and found with the treeline behind it.

6 Reinforce the Focal Point

It's time to take a critical look at the painting. The focal point is the partially hidden door, where the darkest dark and lightest light converge. Changing the stone wall to an adobe wall not only reinforces the focal point, but also makes it easier to correctly paint the sunlight and shadow falling over it.

To make this change, use the same colors you used on the adobe wall of the building, keeping the light and shadow areas separate. It's not necessary to remove the colors you used to paint the wall when it was stone, unless you feel the tooth is too full to take more pastel. If that's the case, use a foam brush to lightly lift off the excess pastel before repainting with adobe colors.

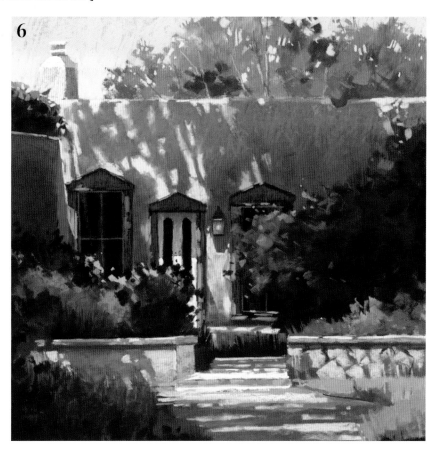

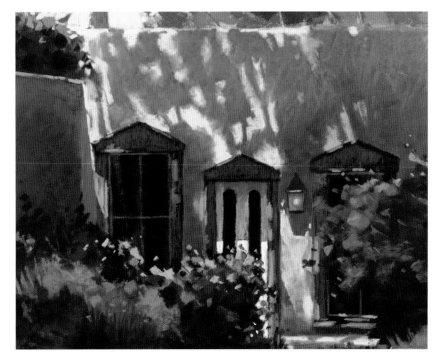

A Closer Look at Sunspots

Sunspots add excitement and interest to a pattern of cast shadows, but they can be easily overdone. A good rule of thumb is to paint only half as many sunspots as you see in your photo. Note that some sunspots combine to make larger, more interesting shapes. Be careful of unwanted shapes though—as you become absorbed in the patterns, you can end up with shapes that suggest something else. Watch out for dogs' heads, alligators and teddy bears!

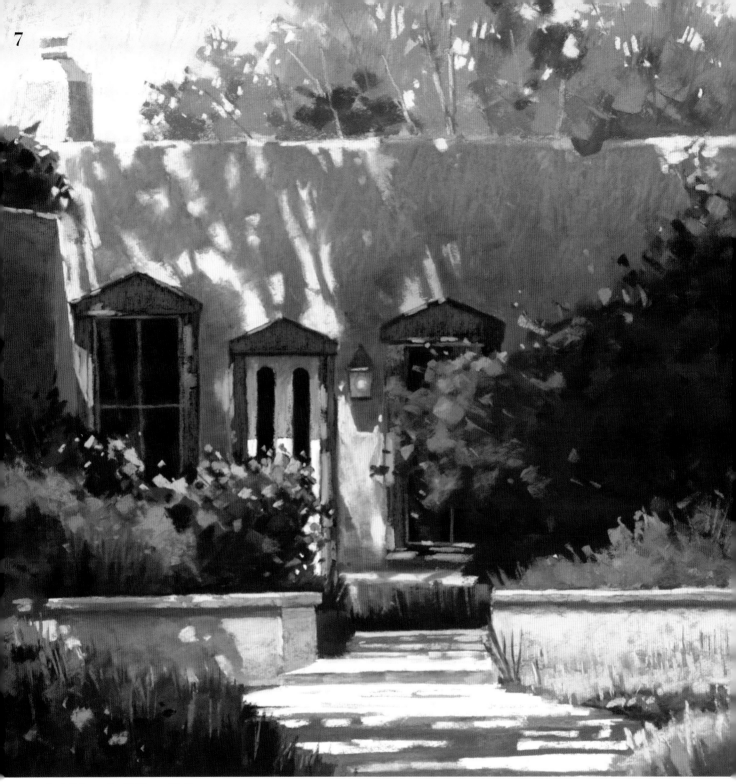

Santa Fe Sunspots - Liz Haywood-Sullivan
Pastel on UArt sanded pastel paper - 16" × 16" (41cm × 41cm)

7 Add Finishing Touches

As you work your way down the painting, finish the masses of plants, making sure to stay consistent with placement of shadows. Keep the bottom left foreground in shadow to allow the eye to move over it and up the pathway. Suggest flowers in this area by painting them one value lighter than the foliage using the same blue-gray pastel you used on the upper edge of the back adobe wall. (Using the same color in various areas of your painting helps unify it as a whole.)

Indicate other flowers without calling too much attention to them by keeping a minimal value difference between them and the foliage. Review all the cast shadows as you finish and make sure they read properly and consistently.

Painting Reflected Light

Reflected light can make shadows lively and interesting. While it doesn't always occur, including reflected light when you observe it can give energy and life to what would otherwise be dull color.

The color of reflected light depends on the color of the object reflecting it. The light bounces off that object and into a shadow. The value may be a little darker than the value of the object reflecting the light, but that's not always the case. Watch for instances of reflected light in your subject, and then analyze it carefully to reproduce the correct color and value.

Materials

SURFACE
20" × 20" (51cm × 51cm) white 4-ply Rising museum board

PASTELS
Rocks: blue-gray, dark green, dark green umber, green, green umber, icy blue, light gray, light ochre, middle-value dark browns, middle-value gray-green, middle-value green, middle-value orange, middle-value olive green, middle-value yellow-green, mustard gold, ochre, rust, slate blue-gray, soft yellow-green

Cracks: dark Prussian blue, dark violet

Foreground: brown, dark Prussian blue, dark violet

Roots and grasses: creams, dark brown, darkest violet, gray, green umber, light gray, middle-value tan, peach, tan, warm orange

Highlights: middle-value gold, orange, peach

WATERCOLORS
Underpainting: dark- and middle-value Burnt Sienna, middle- and light-value Payne's Gray, Titanium White, Ultramarine Blue

OTHER
Nos. 6 and 12 watercolor brushes, standard drawing pencil, tape

REFERENCE PHOTO
Shadowed areas in rock formations often contain reflected light. Its color is usually a slightly darker—and sometimes warmer—value of the color of the rock from which the light is bouncing. Cropping the top and sides of this photo will bring the eye to the focal point, the strong contrast of light and dark on the jutting rock, and the lovely reflected light in the shadow.

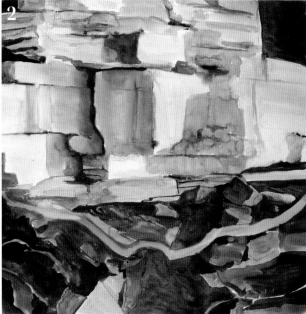

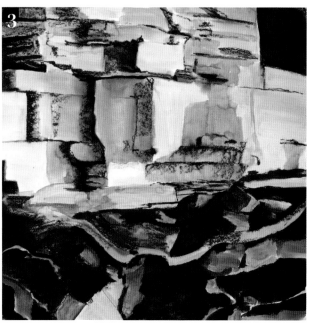

1 Complete the Sketch

Working from the source photo cropped to a square format, lightly sketch the composition with a standard drawing pencil. Make compositional adjustments as necessary, and don't hesitate to omit or rearrange elements.

2 Lay In the Underpainting

Wet the back of your museum board, then flip it over to the front and tape it to your drawing board.

Using dark tones of Payne's Gray and Ultramarine Blue, underpaint the darkest areas in the foreground, in the upper corners and in the darkest cracks in the rock's facade with a no. 6 watercolor brush.

Place dark- and middle-value Burnt Sienna on the rocks scattered across the bottom, as well as the darker shadow faces on the facade.

Use a combination of middle- and light-value Payne's Gray and Ultramarine Blue to finish underpainting the rock's facade, paying close attention to the value structure in the photograph. You want the value of your underpainting to be darker than the final local color.

Apply some Burnt Sienna to warm up the final effect of the darkest cool areas, and place touches of cool blues to help the warm color on the rocks pop.

3 Place Darkest Values With Pastels

Begin laying in the darkest values using various dark blues and browns. Then, strongly indicate the darkest darks with your darkest violet. Use a dark-value Prussian blue for the cracks. Whenever possible, hold the pastel stick on its side to make rectangular strokes of color that will help define the forms.

In the foreground across the bottom, use a variety of dark-value pastels including brown, dark Prussian blue and dark violet to make loose marks, keeping the colors separate.

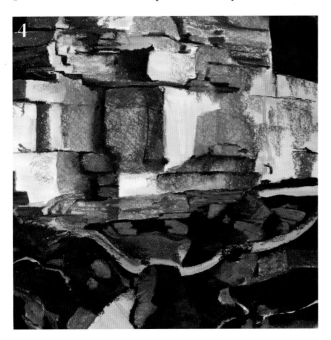

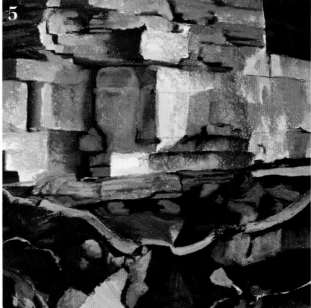

4 Add Middle Values

Start to bring up the dark areas and tumbled rocks across the bottom using middle-value dark browns. Use middle-value orange and rust primarily in the lower left and dark green umber primarily on the right side. These colors are the setup for the final local colors.

Using the dark green umber, lightly go over the initial Prussian Blue on the rock's facade, cracks and shadows. Use middle-value olive greens and slate blue-grays on the darker tumbled rocks.

5 Continue Moving Up the Value Scale

Restate the darkest darks in the cracks. Then, holding your pastels on their sides, lightly skim the next lighter middle-value gray-greens and soft yellow-greens across the rocks to suggest their shape. Play cool and warm tones against each other on these areas to slowly develop the correct value and temperature. All the color work on the rock's facade up until the last application of color serves as a base for the final highlights.

6 Refine Important Forms

Lay in the light middle-value slate blues and blue-grays on the rock's facade. Continue working on all the rock surfaces, bringing up the value bit by bit to allow the layering of colors to create a subtle effect of mottled color. Each addition of color is an opportunity to continue to refine the forms. Repeatedly reassert the darkest darks in the cracks as needed. Add vibrancy to the rock shadows by using middle-value yellow-greens and mustard golds.

Now turn your attention to the forms in the lower part of the painting. Establish the warm oranges, tans and creams in the roots and grasses. Use directional strokes that indicate the shapes of the rough forms and state these lighter middle values and light values clearly. Use dark-value browns, grays and green umber on the dark spots of the large root and light-value grays on the lightest areas. Gently blend these colors with middle-value tans and peach. Develop the grass and debris almost to their final light values. Then, using your darkest violet, soften some of the edges of the lightest lights, pushing them into the dark background.

7 Add Finishing Touches

Create the lightest lights on the rock's facade using light ochres, greens, icy blues and light gray. Exercise great care in refining the forms with these light values,

Natural Geometry - Colette Odya Smith
Pastel over watercolor on white 4-ply Rising museum board - 20" × 20" (51cm × 51cm)

pressing firmly to establish the final forms of the rocks. Drag the pastels vertically or horizontally as needed across the rock surface to indicate shape.

Examine the whole painting for areas that need tweaking. Darken the value of the topmost rocks using dark- and middle-value greens dragged across the lights. Lighten up the entire pale blue section of rock and brighten critical lightest lights with your lightest value gray. Add the light-value vertical rock at the upper right edge for contrast, and add subtle dark violet punches to the dark ground and cracks.

Check the overall value across large mass areas and increase the lightest value on the tumbled rocks. Then gently lay in the warm reflected light in the shadow faces using light and light middle-value golds, oranges and peach. Add notes of warmth to the most important white rocks using the same colors.

Making the Shadow Your Subject

The pattern of a cast shadow can sometimes be more intriguing than the object that casts the shadow. When you have a dramatic shadow with an interesting shape, consider making it the subject of the painting.

In this demonstration, the subject is closer to the viewer than the average landscape; thus, more detail is required to render it properly. Careful attention to the shape of the shadow is most important, as it will be the focal point of the painting.

REFERENCE PHOTO
The photo was taken on a winter afternoon. While the light in the photo looks a bit flat, it was, in fact, quite warm. The contrast of the warm light spots against the cool blue shadows was the reason for the photo.

Materials

SURFACE
18" × 24" (46cm × 61cm) white Richeson premium pastel surface

PASTELS
Bricks: pale pink, pale peach, pale gray

Exterior: beige, blue, gray, green, light green, peachy yellow, pink, very light blue, warm gray

Flowers: bright pink, bright red, dark red, light pink, magenta, middle-value pink, red

Leaves: dark blue, dark eggplant purple, dark green, light yellow-green, middle-value green, orange, very dark blue-green, yellow, yellow-green

Pots: brown, burnt sienna, charcoal gray, dark brown, light orange, middle-value orange, red, reddish brown, umber, yellow-orange

Shadows: black, blue-gray, charcoal gray, dark blue-green, dark brown, dark lavender-gray, eggplant purple, lavender-gray, middle-value dark blue-purple, middle-value blue, neutral gray, very dark brown, very dark charcoal gray

Underpainting: black, brown, burnt sienna, dark brown, dark charcoal gray, dark eggplant purple, dark green, dark orange, light blue, light green, light yellow-green, light yellow ochre, middle-dark blue-gray, middle-dark rusty brown, middle-value gray, middle-value red-orange, middle-value yellow-green, middle-value yellow ochre, orange, pink, red, yellow ochre

Woodwork: brown, burnt sienna, dark brown, dark red-orange, dull orange, eggplant purple, middle-value rusty brown, reddish-brown, red-orange, very dark brown

PASTEL PENCILS
Sketch: burnt sienna

Grid: dark gray

Bricks: black, burnt sienna, charcoal gray, dark blue, middle-dark blue-purple, middle-value blue, middle-value gray

Other: dark blue-green, dark brown, dark green, gray, light ashy green, light brown, middle-value brown, orange, peach, reddish brown, red-orange, soft light green, umber brown, yellow, yellow-green, yellow ochre

OTHER
½-inch (12mm) synthetic brush, kneaded eraser, ruler, Turpenoid

1 Complete the Sketch

Because the perspective in the reference photo was skewed by the camera, the vertical lines of the window frames need to be corrected in the drawing. Use your burnt sienna pastel pencil and a ruler to make the vertical lines straight and correct the perspective of the horizontal lines. Remove any mistakes with a kneaded eraser. Then draw the foliage, lightly placing color on the spots where the blossoms will go to help keep track of their position.

As always, consider what can be omitted. In this case, the folded table to the right is a distraction, and the bits of foliage and flower on the left side are awkward.

2 Lay In the Underpainting

Choose colors from the "underpainting" section of the materials list for this step.

Using mostly hard pastels, carefully lay in a light layer of color for the underpainting. If you use densely pigmented hard pastels, you won't need to cover the surface heavily to get enough pigment. The subsequent Turpenoid application will let you spread the pastel around. As you work, remain open to compositional changes, such as adding a few more blossoms to the middle geranium plant.

Use soft pastels for the large area of shadow. Hold the pastels on their sides and skim a light layer of color, being careful not to fill the tooth.

3 Wash With Turpenoid

Using your ½-inch (12mm) synthetic brush, carefully wash each area of color with Turpenoid, beginning with your lightest values. Keep the colors clean and separate, and try to avoid runoffs or blotchy areas. Allow your surface to dry before moving on.

4 Establish the Value Range

It always helps to establish the value range immediately. Since the lightest colors aren't much lighter than the underpainting in those areas, leave them as they are.

Lay the darkest darks in the shadow area using eggplant purple, dark brown and charcoal gray. The shadow of the plants gets lighter as it moves away, so place the darkest darks only partway across. Keep the shadow of the closest pot a little darker than the others. Along the darkest bottom edge of the woodwork, lay in very dark brown and eggplant purple.

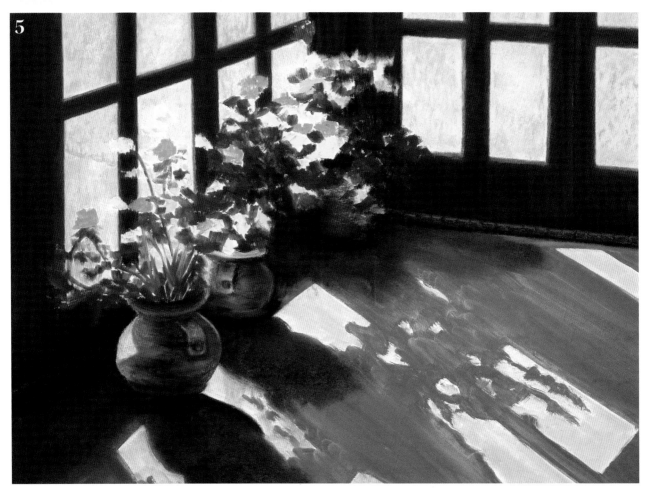

Define the Window and the Area Outside

5 Although this scene is lit with natural sunlight, it's indoors. Because of the quality of the glass and the angle of the light, what you see of the outdoors is muted and indistinct. Painting it that way will help keep the focus on the subject.

Using several soft pastels in light green, gray and blue, paint the grassy areas. Indicate shadows, including those along the edge of the sidewalk, with blue. Paint the sidewalk using beige and gray of the same value. Tap lightly with your finger to soften and blend the colors.

Using a combination of very dark brown and eggplant purple, darken the wood in the back corner and on the left front where it receives less light. As you work your way up, move to lighter values of dark brown and burnt sienna. Use a dark red-orange to paint the thin lines of light, which help define the dimension of the wood. Be careful to keep your lines straight and even, using pastel pencils and a ruler if you need to.

Paint the Flowers and Pots

6 Lay in the dark shadows of the foliage using eggplant purple and dark blue-green. Use middle-value greens to define some of the leaves. Where the leaves are in deep shadow, add touches of dark blue. Use yellow-green, orange and yellow to define those leaves struck by sunlight, keeping the edges crisp.

Paint the geranium blossoms by dotting in small spots of color. Use bright red and dark red for the red blossoms, and bright pink, magenta and light pink for the pink blossoms.

The pots are fairly well defined by the underpainting, but in some areas the values are too light. Darken these areas and tighten up their edges. Note that the most distant pot is different in shape from the other two and that it is mostly in shadow. Leave this pot fairly indistinct to suggest distance and keep the perspective correct. Use dark brown, charcoal gray, reddish brown and umber for the pots.

Suggest the Brick Floor

7 Using a dark gray pastel pencil and a ruler, draw a grid on the floor surface, roughly suggesting the placement of bricks. Keep the most distant horizontal line parallel to the row of upright half-bricks that form the doorsill. Space the lines out farther as the bricks come toward you to create the feeling of distance.

Getting the perspective right on the brick floor is very important; if it's wrong, the bricks will not "lie down." Take your time, and make any necessary adjustments before moving on.

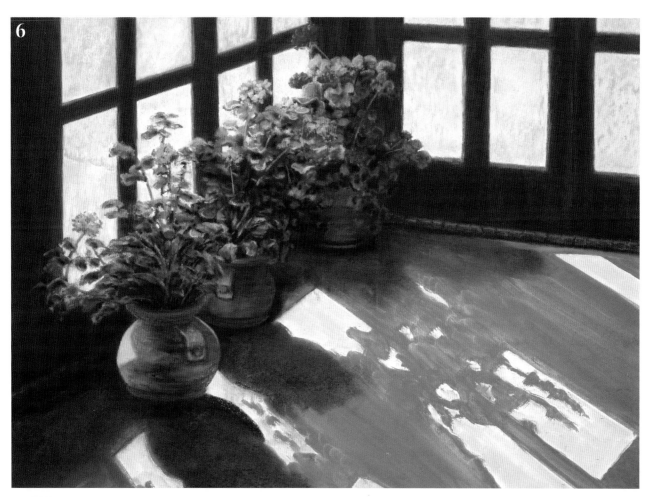

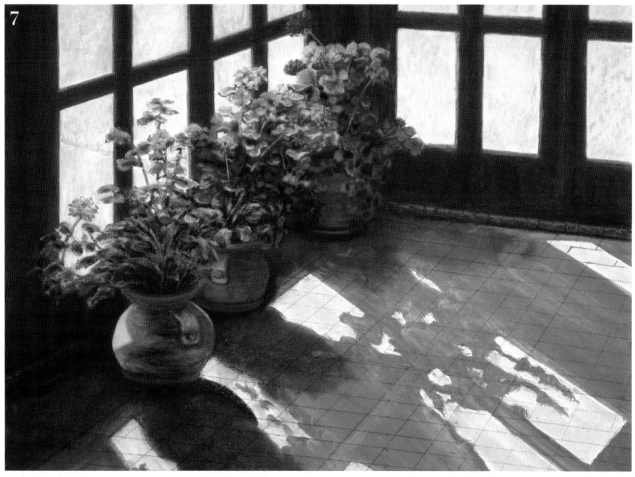

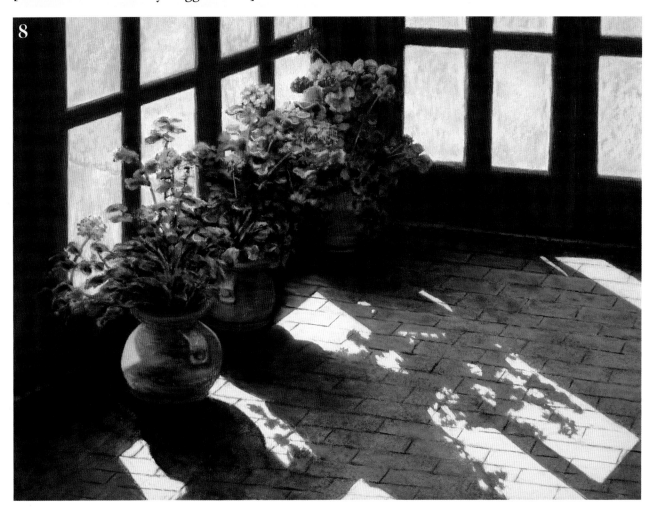

8 **Continue Developing the Bricks**
Beginning with the farthest row, paint each row of bricks, covering up unnecessary lines as you go to suggest the appearance of offset rows. Use dark blue, middle-value blue, middle-dark blue-purple, charcoal gray and a black or charcoal gray pastel pencil to refine the bricks in shadow.

Paint the bricks in sunlight using pale pink, pale peach, pale gray and pastel pencils in burnt sienna and middle-value gray. Note that the shadow is darkest close to the back wall and to the front of the pots that cast the shadow, so graduate to slightly lighter values as you work your way forward.

Not all the edges of the bricks are visible; the lines disappear and reappear both in shadow and in sunlight.

Draw the edges in sunlit areas using a combination of the burnt sienna and charcoal gray pastel pencils.

9 **Add Finishing Touches**
Finish the brick floor. Give some bricks uneven edges and add dark or dirty spots to others. These elements make the floor more realistic without being too distracting.

Darken the geranium blossoms in the middle pot using bright red and dark red pastels. Clean up the edges around the pots and around the foliage in the foreground pot, then bring a few leaves of the closest plant into sharper focus.

Finally, soften the transition of the shadow where it moves from very dark at the base of the pots to the lighter value in the middle of the painting. Check once more for any edges that need to be sharpened or lost, making corrections as needed.

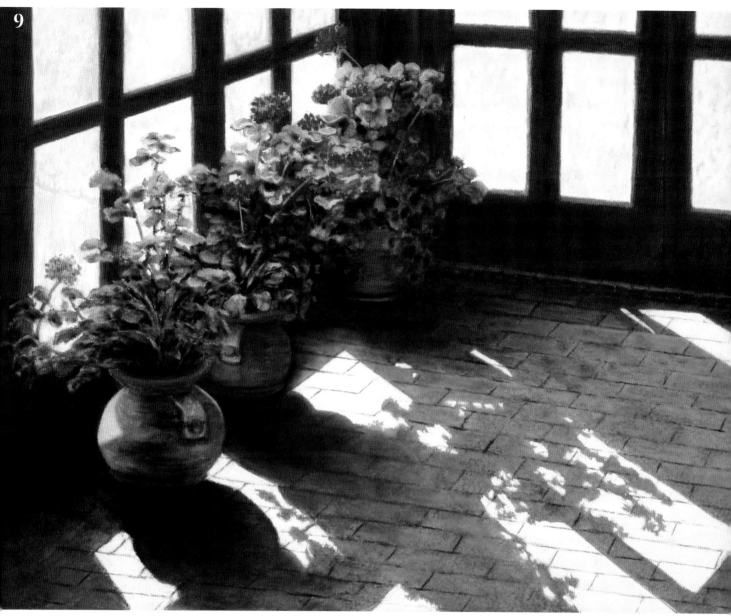

Shadowplay - Maggie Price
Pastel on Richeson premium pastel surface - 18" × 24" (46cm × 61cm)

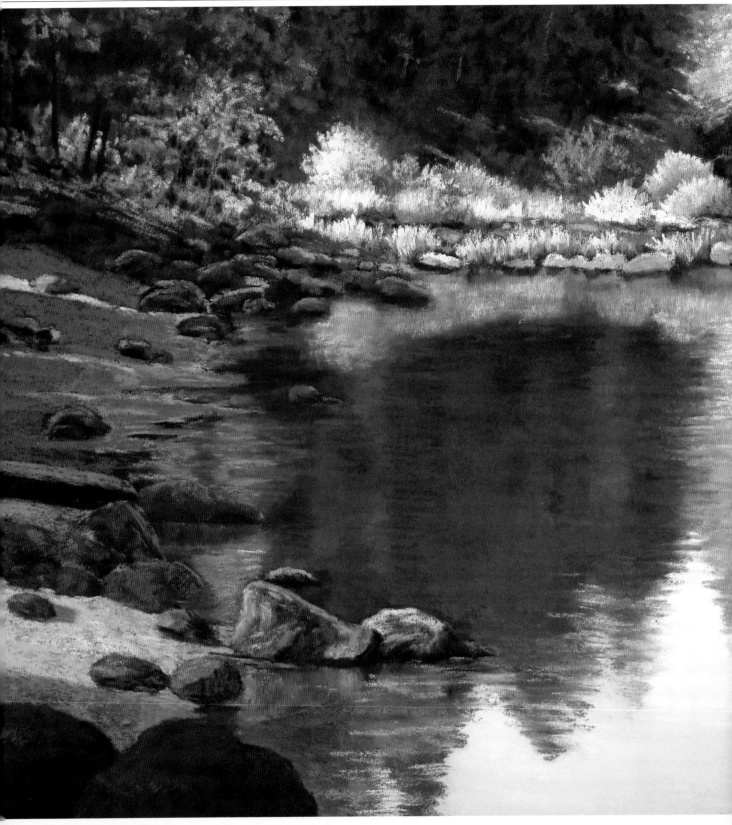

Quiet River - Maggie Price

Pastel on black Richeson premium pastel surface - 18" × 24" (46cm × 61cm)

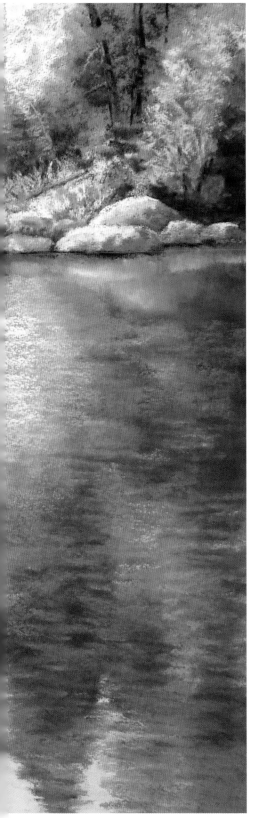

Painting Lifelike Reflections

In addition to painting objects, people and landscapes, artists are often drawn to painting water. Light and shadow not only describe the form of water—its flatness, stillness or movement—but they also affect our visual perception of the water itself, its depth, color and transparency.

Numerous factors, including the angle of the light source and the resulting shadows, can strongly affect how we perceive reflections. Still water may offer mirror-like reflections. Moving water breaks up and distorts reflections or eliminates them entirely. And the color of water can change drastically from one moment to the next as the light from the sun is affected by passing clouds.

In this chapter, we'll explore several factors that influence the appearance of water's reflective surface, learning more about how to portray light, shadow and reflections accurately when painting water.

Notice the Angle of Light

The angle of light determines exactly where shadows fall, changing the color and value of reflections accordingly.

Locate the Sun

When studying how light impacts the appearance of reflections, first consider the appearance of the sun.

In midday, when the sun is more or less directly overhead, you may observe picture-perfect reflections—those mirror images of land mass or mountains that could work almost as well upside down as when correctly viewed. But in morning or late afternoon light, when the sun is lower in the sky, reflections may be crossed by cast shadows, presenting exciting challenges to the artist.

The Value of a Reflected Color

It's not uncommon for color to vary from the object to its reflection. As a general rule, light values tend to reflect a little darker, while dark values may reflect a little lighter. For example, observe a light-colored tree on the edge of a body of water, and note its value. Then look at its reflection and compare the value; you will usually find that it is a little darker. Depending on the time of day and the color of the light, the reflected color may also be a little warmer or cooler.

The depth of the water and the color of the rocks or ground underneath the surface can also affect the perceived color of the water itself. Very deep water tends to be deep blue, while shallow water may appear to be the color of the ground or rocks beneath it.

Because there are so many variables, this rule may not hold true in every case, so it's always a good idea to pay close attention to color, value and temperature shifts when painting reflections.

Coming Home - Colette Odya Smith
Pastel on 4-ply Rising museum board - 20" × 20" (51cm × 51cm)

PAINTING LIGHT, SHADOW AND REFLECTIONS IN LATE AFTERNOON LIGHT

Late light casts long shadows across the water, creating an abstract pattern which interplays with the vertical tree trunks. Reflections always come toward the viewer, while cast shadows are positioned relative to the light source (the sun). Even in this intimate study, the artist has conveyed a sense of depth and distance by using increasingly lighter and grayer values as the subject recedes in the picture plane.

Consider the Position of the Viewer

The position of the viewer can drastically affect the appearance of reflections.

Test Your Reflection

Test this theory by looking in a mirror. When you stand directly in front of the mirror, you see your own reflection, plus the reflection of whatever is directly behind you. Now move off to the side and look in the mirror again. Depending on how far you moved, you may or may not see any of your own reflection, and the reflection of the rest of the room will have changed significantly.

Paint What You See

When you're painting the reflection of objects in nature, the position of the viewer is always assumed to be in front of the object being reflected. However, to understand reflections, you must also take into account the viewer's vertical position. What you see reflected if you are sitting on the ground next to the water is very different from what you would witness standing on a second-floor deck. So when you're painting reflections, it's best to paint exactly what you see reflected, whether in a photograph or in life, as your position will always affect what and how objects reflect.

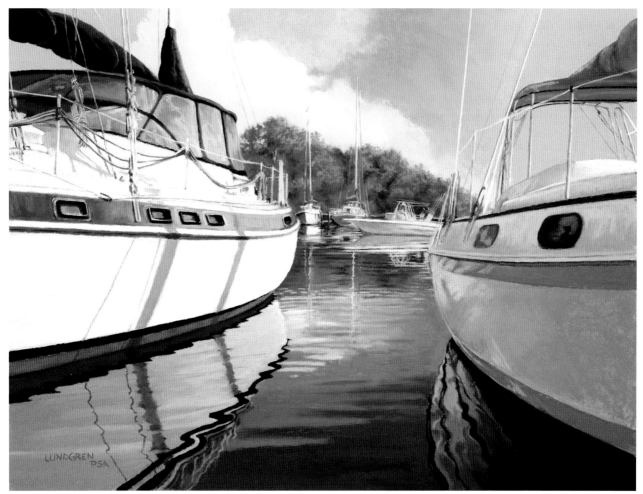

LOOKING ON FROM A LOW ANGLE

Because the position of the viewer is low, only a small amount of the left boat's cabin reflects. Most of the reflection is of the boat hulls. The gentle ripples in the water distort the reflections a little, and the reflection of the light-colored boat on the left is a darker value than the boat itself. The boats in the background, as well as the trees, clouds and sky, are also reflected, but the distance and turbulence in the water make those reflections less distinct.

Heading Out - Richard Lundgren
Pastel on Wallis professional-grade sanded paper
18" × 24" (46cm × 61cm)

Survey the Angle of the Land Mass

The only way to paint accurate reflections is to observe them carefully, painting what you see, not what you expect to see.

Angles Affect Reflections

When the surrounding land mass slants sharply backward, away from the water, reflections cast upon the water may not match what you see on land. In fact, it's fairly common for reflections not to include trees or other objects located farther back on the plane that's being reflected.

The angle of the land mass can also affect how much of an object is visible in a reflection. For example, perhaps there is a prominent tree near the water's edge. Judging from the angle of the light source, you might guess that the trunk of the tree will be reflected. However, when you look at the reflection on the water's surface, you may be surprised to see a different portion of the tree than you expected.

Of course, the angle of the land mass works in conjunction with the angle of the light source and the position of the viewer to create unique, ever-changing reflections.

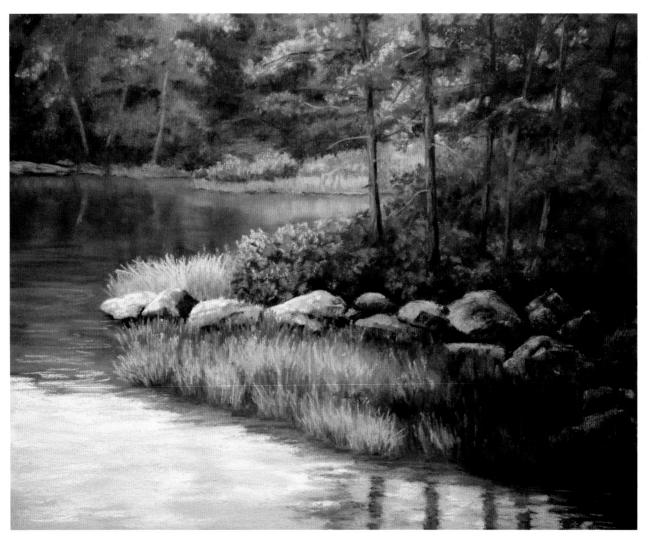

THE INVISIBLE SKY
This painting illustrates just how different a reflection can be from what you see on land close to the water's edge. The reflection on the water's surface in the lower portion of the painting shows tree trunks surrounded by reflected sky and clouds, which you actually don't see in the painting.

Calm on the Kennebec - Maggie Price
Pastel on white Richeson premium pastel surface
16" × 20" (41cm × 51cm)

Examine Shadows Crossing the Water

When shadows cross the water, not only do they affect the color and value of the water's surface, but they also dramatically change both the colors we see in reflections and the colors of those objects below the surface.

Though it's not always easy to determine the exact color of the bottom of a river or a stream, this color lends an overall tone to the water. For instance, orange or golden sands and brown mud give the water an orange cast. However, when shadows cross the surface of this water, the orange becomes a rich brown. Likewise, very deep water tends to be bluish in color, but shadows crossing such surfaces shade the water, making it appear much darker.

Regardless of the color of the water, it's safe to assume this general rule will apply: Shadows alter the colors visible in reflections and affect the color of submerged objects.

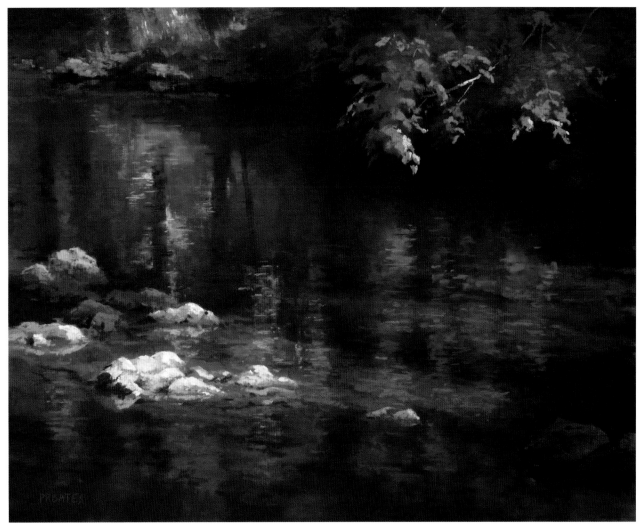

EXPLORING THE DEPTHS
The sky, outside the picture plane, reflects lighter blue in sunlit areas and darker blue in the shadows. The orange-gold bottom of the stream is in the light. The rocks in sunlight cast a reflection onto the water, but the rocks at the bottom right, in full shadow, do not reflect.

What Lies Beneath - Phil Bates
Pastel on UArt sanded pastel paper
16" × 20" (41cm × 51cm)

Painting Reflections in Still and Moving Water

Reflections in still water are more distinct than reflections in moving water, which are broken up by the movement. Sometimes the water surface is barely rippled by the flow of the stream or ruffled by the wind, but even these small disturbances can affect the reflection. Reflections in still water are more likely to follow the rule of value changes: Light values reflect slightly darker, and dark values reflect slightly lighter.

REFERENCE PHOTO
The focal point is the water itself, crossed dramatically by the diagonal branch lying across the surface. The distant trees in the top left and the bridge and stones in the upper right will establish the depth in the image, while the area of smooth, mirror-like reflection will contrast with the moving water in the foreground.

Materials

SURFACE
20" × 20" (51cm × 51cm) white 4-ply Rising museum board

PASTELS
Background trees and foliage: black-green, browns, cool green, cream, dark warm green, earth green, grass green, green-gray, green umber, light-value blue-green, light-value green, middle-value blue-greens, neutral gray, orange ochre, pale sienna, raw umber, rust, sienna, very dark brown, very light creams, very pale gray, warm tans, warm white, yellow-green, yellow ochre

Branches and leaves: black-green, brown, cool green, cream, dark blue-gray, dark brown, dark earth green, dark-middle blue-green, middle-value dark tan, green umber, gold ochre, light-value gold ochre, light-value rose, middle-value grass green, middle-value yellow-green, orange ochre, pink, raw umber, rose, rust, warm green, warm olive green, yellow-green

Bridge: blue, blue-gray, cream, magenta, mars violet, middle-value blue-gray, middle-value blue-violet, orange ochre, pale gray, very dark violet, very light neutral gray, white

Fallen branch: blue, blue-gray, brown, light-value mars violet, magenta, mars violet, middle-value blue-gray, middle-value tan, neutral gray, pale violet, pink gray, red earth, red violet, rose, rust, tan, very dark violet, violet

Rocks: blue, blue-gray, blue-green, green umber, light-value gold ochre, light-value pink-gray, mars violet, middle-value blue-gray, middle-value blue-violet, neutral gray, pale umber, pink, pink-gray, red-violet, very dark violet, violet

Water: blue gray, blue-violet, cool green, cream, darker cobalt, dark-value blue-gray, grass green, green-gray, middle-value light ultramarine blue, light-value ultramarine blue, mars violet, middle-value cobalt blue, ochre, olive green, pink, red earth, rose, ultramarine blue, very light neutral gray, violets, white, yellow-green

WATERCOLORS
Underpainting: Alizarin Crimson, Burnt Sienna, Burnt Umber, Dioxazine Violet, Payne's Gray, Raw Umber

OTHER
Kneaded eraser, nos. 6 and 12 watercolor brushes, old stiff bright brush, standard drawing pencil, tape

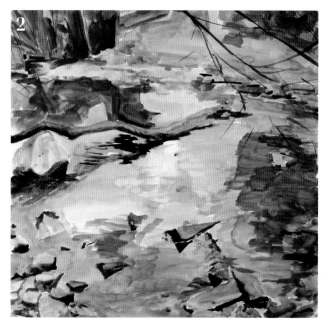

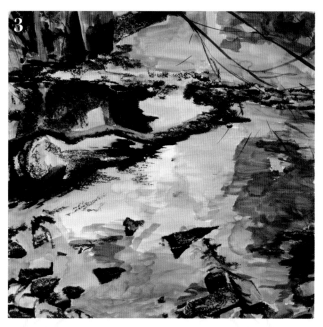

1 Complete the Sketch
Working from the reference photo cropped to a square format, lightly sketch the composition with a standard drawing pencil. Make compositional changes as you go, eliminating the long curving branch to the right and any other elements you find distracting.

2 Lay In the Underpainting
To prepare the museum board for underpainting with watercolor, wet the back side of the board, then turn it over and tape it to your drawing board.

Using both dark and light value washes of Payne's Gray, lay in the underpainting for the rocks, deep shadows and darkest distant trees.

Lay in the underpainting for the lightest white areas using Burnt Sienna. Use the no. 6 brush for the smaller forms like the rocks, the tree branches and the dark water ripples, and the no. 12 for loosely filling in the broader color areas.

Use a combination of Raw Umber and Burnt Sienna for areas under the dark greens, shifting to just Burnt Sienna with a touch of Alizarin Crimson for the paler green areas.

Finish the underpainting for the blue water areas with varying values of violet. Allow this to dry completely.

3 Place the Dark Values With Pastels
Use the very dark-value violet and blues for the shadowed sides of all the rocks, but add blue-green on the midground and foreground rocks to make them warmer. Keep the very dark-value violet predominant on the bridge shadows and its reflection and the background rocks. Use the browns, earth greens and black-green in the upper left background foliage and its reflection. Add brown over the violet and blue on the fallen log.

4 Block in the Water

Lay in the blue base colors of the water. Don't worry about keeping the edges of the rocks neat. Begin with the darker cobalt and ultramarine blues, then move to the lighter middle values, leaving areas of the underpainting showing through. Leave the greens and sienna tones exposed between the blue pastel. Lightly blend with your finger where the water is smoothest.

Lay in strokes of middle-value blue-grays and violets on the far rock line. Also use these colors on the angled shadow on the bridge foundation. Lightly suggest the bridge foundation and reflection with your lightest creams and gray. Strengthen the dark violets and blue-grays under the rocks, fallen log and shadow reflection.

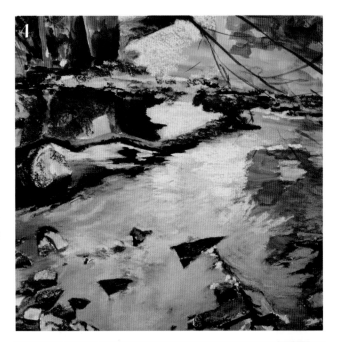

5 Paint the Distant Objects

Beginning with your darkest green and moving to the lightest, refine the distant foliage in the upper left. Alternate between warmer and cooler greens to differentiate the trees. Place quick, small strokes of yellow ochre, cream, pale sienna and very pale gray to define the trees and their reflections, keeping the reflections a bit darker and duller. Smooth the reflections as necessary with light finger-blending, then add a couple of pops of warm white, light-value yellow-green and rust for highlights. Lay in quick strokes of green-black for tree trunks and branches. Scumble dark warm greens and very light-value greens in the upper right, keeping the area indistinct.

Lay in the mass of the bridge and its reflection with cream, pale gray and white. Do the same for the rocks in the upper right, using ochres and pale umbers to softly define forms. Add touches of rust, pale violet, magenta, red earth and pale blue-greens to distinguish and emphasize areas along the fallen log and debris, the far rock line, and the leaves along the foreground rocks.

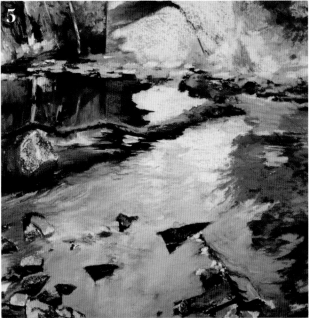

6 Refine Shapes

Refine the shadows on the bridge using middle-value blue-grays. Restate the walkway at the top of the image and redefine the fallen log with your deepest violets. Finish the log with highlights of pale violet, blue-gray, middle-value tan and mars violet.

Add earthy dark and middle-value greens, ochres, yellow-greens, grass green and cool green along the right of the water. Refine the ripples along the left, adding dark blue-gray against the middle-value cobalt blue. Add dull green reflections under the branch and in the foreground. Place dark and pale violets over the blue in the foreground and gently finger-blend as needed. Add touches of red earth, rose and pink to the water and leaves.

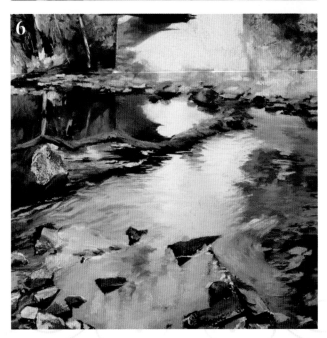

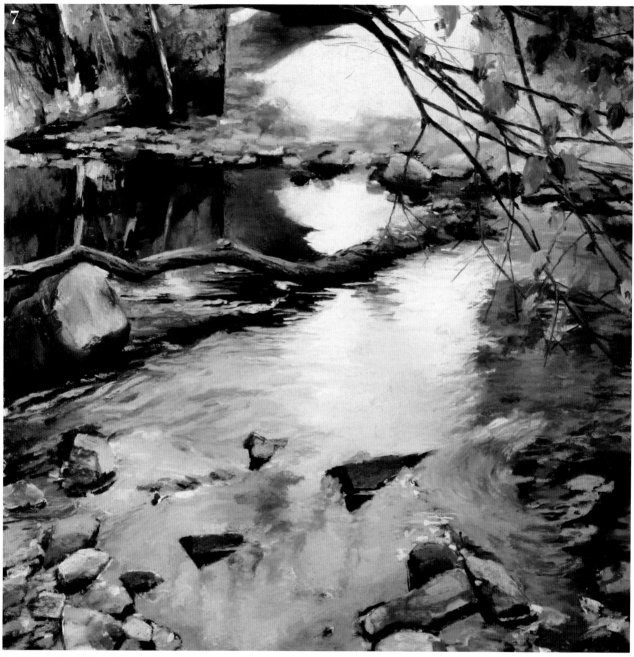

The Bridge - Colette Odya Smith
Pastel over watercolor underpainting on 4-ply Rising museum board - 20" × 20" (51cm × 51cm)

7 Add Finishing Touches

Roughly stroke in middle-value and light-value grays, blues, pinks and violets across the foreground rocks to define them, making sure to vary the temperature and values within a tight range. Retouch the darkest areas as needed to strengthen them. Touch in light-value creams and ochres, rose and pink for the clustered leaves.

Using an old bright brush, remove the pastel dust carefully where the tree branches. It will be easier to apply the dark grays, violets and tans into a light-value area. It also allows you to easily spot and correct drawing errors.

Lay in the dark-value branches confidently, using delicate strokes for fine branches. Draw the close leaves with a dark-value warm green, middle-value yellow-green, light-value gold ochre and a dark brown. Slightly vary the size of the leaves and leave them somewhat soft-edged and undefined.

Depicting Shadows Cast on Reflective Surfaces

The interplay of shadows and reflections can create a wonderful subject. Areas where shadows cross reflections can be rich and dramatic. When you combine these elements with children on a beach, you can create a powerful composition that transcends the somewhat trite subject and takes it to a new level.

Materials

SURFACE

18" × 24" (46cm × 61cm) white professional-grade Wallis sanded pastel paper

PASTELS

Beach: light cobalt blue, light neutral gray, neutral gray

Cast shadows and reflections: burnt carmine, cinnamon, cobalt blue, dark neutral gray, dark walnut brown, Indian red, middle-value carmine, middle-value cobalt blue, middle-value orange, neutral gray, sepia

Faces and figures: blue-violet, burnt sienna, cinnamon, Indian red, light flesh, light orange, middle-value flesh, middle-value golden ochre, middle-value orange, Pompeian red, Van Dyke brown, white

Hair: burnt sienna, light blue, light green earth, light pale yellow, neutral gray, white

Sand pails and shovels: light orange, light turquoise blue, middle-value neutral gray, middle-value orange, middle-value turquoise blue

Swim trunks: burnt carmine, dark indigo blue, dark orange, light carmine, light gray, light orange, middle-value cobalt blue, middle-value carmine, middle-value orange, orange, Prussian blue, white

Underpainting: neutral gray

PASTEL PENCILS

Faces and figures: brown ochre, cinnamon, walnut brown

Sand pails and shovels: light turquoise blue, middle-value orange, middle-vale turquoise blue, white

Swim trunks: middle-value orange

OTHER

1-inch (25mm) synthetic watercolor brush; mineral spirits; nos. 2, 2B, 4B and 9B pencils; no. 2 flat color shaper; one sheet of white 50-lb. (105gsm) drawing paper

REFERENCE PHOTO
This is the best of about thirty pictures taken of the boys on the beach. Still, minor adjustments need to be made to the boys' hands during the sketching phase.

While the figures themselves are interesting and will catch the viewer's eye, the way the cast shadows cross the reflections of the children is especially interesting. The reflections come toward the viewer while the shadows are cast from the sun shining on the boys' backs. Where the shadows cross the reflections, the reflections will darken considerably.

Using an underpainting for the background will tint the paper close to the color of wet sand. Because water covers most of the sand, the underpainting helps create the illusion of texture.

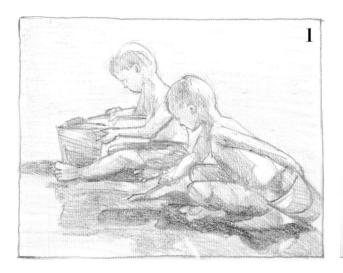

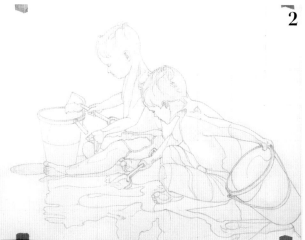

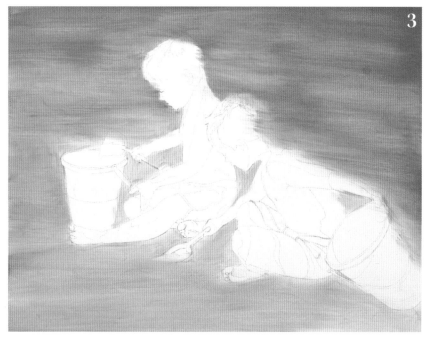

1 **Complete the Sketch**
Using the assortment of pencils (nos. 2, 2B, 4B and 9B), create a value sketch paying careful attention to proportions. Make compositional decisions such as keeping the figures to the right and cropping the sand pail on the right by the edge of the painting. To make the painting more interesting, the position of the hands is changed in this step.

2 **Transfer the Drawing**
Enlarge the reference photo to 8 ½" × 11" (22cm × 28cm) and mark with a 1-inch (25mm) grid. With 2⅝-inch (7cm) squares, lay out the grid on a piece of 50-lb. (105gsm) drawing paper the same size as the finished paint-

ing. Draw the figures using the grid to check the accuracy of your drawing, then transfer the drawing to your surface by blackening the back of the drawing and tracing it onto your surface.

3 **Underpaint the Background**
Lay in a light coat of soft neutral gray using the broad side of your stick. Then, using mineral spirits and your 1-inch (25mm) synthetic brush, dissolve the pastel into the surface of the sanded paper, yielding a color similar to that of wet sand.

Because this is a complex composition, refrain from underpainting any further. Instead, move on to painting the figures.

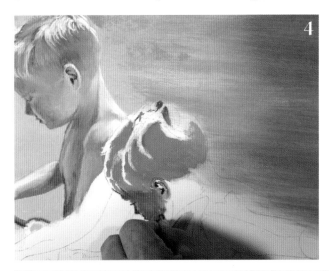

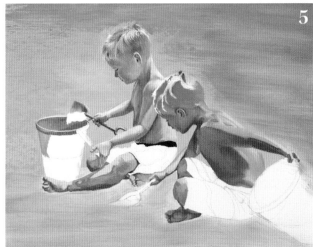

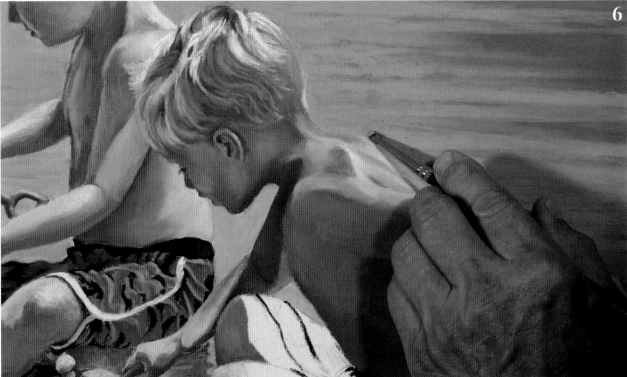

Paint the Faces and Color the Hair

4 Once the underpainting dries, paint the boys' faces and hair, keeping the lighter, more golden colors where the sunlight strikes the skin. Keep in mind though, that even in shadow, the skin tones pick up warmth from the light reflected off the wet sand.

For the faces, block in the large areas in shadow using hard pastels of burnt sienna, Indian red and cinnamon. Begin refining the features using middle-value golden ochre, middle-value flesh, light flesh and white.

For the ears, use middle-value orange, light orange, Pompeian red and Van Dyke brown. Blend some of the face color into the hairline. Use brown ochre, cinnamon and walnut brown pastel pencils for the eyelashes and lips. Gray the skin in shadow areas with a light glaze of blue-violet.

For the hair, begin with the darkest areas in shadow. Use the same neutral gray used in the underpainting, along with burnt sienna and a light green earth. For the light highlights on the hair, use a very light pale yellow and white. Then add a little light blue around the boys' heads to help the figures stand out against the background sand.

Lightly blend the colors using your fingertip. The side of a pastel pencil is also useful in blending or feathering one color over another.

Block In the Figures

5 Using the same pastel colors used for the faces, block in the boys' torsos, arms and legs. Start with the darkest areas and work toward the lighter areas. Pay particular attention to getting the transition between areas in light

and shadow correct. Don't finish these areas—it's better to first block in all of the figure, then come back and refine, blend and finish the fine details of the hands and feet.

Begin the outline of the boy on the left's shovel, sand pail and swimming trunks using a middle-value orange pastel pencil and a hard, light orange pastel to preserve the edges of the shovel from the background so the shapes won't be lost as you continue to work.

6 Finish the Figures and Fill In the Swim Trunks on the Left

Finish the figures the same way you finished the faces. Use a color shaper to get the edge between the figure and the background correct. Drag the shaper over areas of slight buildup in the background to create a clean line. Be sure to clean the tip of the shaper between strokes so as to not transfer color.

Paint the swim trunks for the boy on the left, starting with the darkest indigo blue pastel and then adding in the dark orange, middle-value orange and light orange. Finally, paint the white stripe using hard pastels in white and light cool gray.

7 Color In the Sand Pail on the Left and Build Up the Background

Finish the pail on the left, beginning with a hard pastel in middle-value orange, followed by a softer pastel in light orange. Over the middle-value orange of the sand-filled portion at the bottom of the pail, lightly skim on a middle-value neutral gray soft pastel. Paint the handle with middle-value turquoise blue and light turquoise blue pastels.

Begin building up the background area of the beach using a light soft cobalt blue, a light neutral gray and the neutral gray used for the underpainting. Use long horizon-

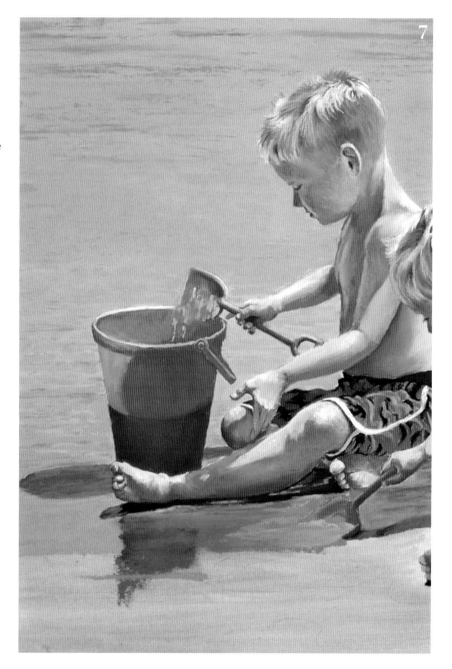

tal strokes to capture the gentle action of the sea rolling in. From left to right, fade the cobalt blue into the darker areas of the beach on the right.

Establish the cast shadows around the figure on the left. For the shadow cast by the sand pail, block in the area using the soft neutral gray used in the underpainting. Glaze this with a soft middle-value cobalt blue.

Using hard pastels in sepia and dark walnut brown, paint the shadow area under the left leg of the boy on the left. Add a few touches of the cobalt blue used in the background to indicate reflections on the dark shadow. Indicate the reflection of the sand pail using a dark neutral gray, then glaze over this with a hard middle-value orange.

8 **Paint the Pail on the Right**
Outline the penciled line of the pail on the right with sharpened hard pastels in light orange and middle-value orange, or use pastel pencils in similar shades. Do the same for the turquoise blue handle. Having established the edges of the pail, fill in the rest of the color, paying attention to where the sun shines through the pail and creates highlights.

9 **Block in the Swim Trunks on the Right**
To capture the Hawaiian print of the swimming trunks on the boy to the right, begin by blocking in the darkest blue of the trunks as shown in this detail. The trunks can be loosely defined since the patterns will be abstracted in the final rendering.

Begin with a hard dark indigo blue pastel. Next use a hard Prussian blue and a hard middle-value cobalt blue. Then add the red in the pattern using a hard burnt carmine. Indicate the lighter reds with a hard middle-value carmine pastel.

10 **Add Finishing Touches**
Complete the swim trunks of the boy on the right using hard white and hard light gray pastels to indicate the white outline of the print. Refine the pattern using the same colors you used for blocking in. Add a few highlights of lighter values of the same reds and blues used to complete the trunks.

With the same neutral gray used for the shadow cast by the pail on the left, paint the shadows cast by the boy and sand pail on the right. Again use a soft middle-value cobalt blue to glaze the shadow. Within this shadow area, add darker values of the reflected colors of the swim trunks and the boys' skin tones. To finish the shadow, add a little light neutral gray to indicate the light reflected under the pail.

Complete the reflections cast by the boys with a lighter tone of the neutral gray used in the cast shadow. Indicate the reflections of the boys' skin with darker values of the colors used to fill in their figures.

Finally, add some soft cobalt blue to the reflections to indicate wet areas of the sand.

Luke and Jake - Richard Lundgren
Pastel on Wallis sanded pastel paper - 18" × 24" (46cm × 61cm)

Studying the Effects of Light on Objects Submerged in Water

Have you ever picked up a handful of beautiful stones or shells on a beach, taken them home and then been disappointed in the colors when they dried? Water changes the color, value and intensity of an object. Painting partially submerged rocks or branches is a fascinating exercise in observing this change.

Sunlight shining through the water also affects the perceived color of the submerged object. Add in the reflections on the surface of the water, and you have a complex study of some of the effects of light on water.

REFERENCE PHOTO
The rocks and fallen leaves are both under the water and sticking out above the water, illustrating the difference that water makes to their color and value.

It's easier to distinguish the rocks and leaves underwater when they are somewhat shaded by the overhanging trees. The underwater rocks on the left side, in full sunlight, are more difficult to see because the sunlight also bounces off the surface of the water, reflecting the blue sky so strongly that the definition of the rocks is more subtle.

Materials

SURFACE
20" × 20" (51cm × 51cm) white 4-ply Rising museum board

PASTELS
Branch shadows: dark-value burnt umber, middle-value browns, middle-value umber, tan, umber, very dark violet

Highlights: cream, light-value blue-gray, light-value ochre, middle-value peach, rose

Leaves: bright orange, cream, dark burnt umber, dark rusts, gold, gold ochre, light-value cool green, middle-value cool greens, orange, middle-value peach, light yellow, pink, raw umber, rusts, strong peach, very light-value cool greens, warm greens, white

Dry rocks: cool green, dark-value blue-gray, dark blue-gray, dark earth green, light-value ochre, middle-value blue-gray, neutral gray, peach, raw umber, very dark-value browns, very light-value neutral grays, violet, white

Underwater rocks and leaves: blue-gray, burnt umber, cool green, dark cool brown, middle-value dark cool brown, middle-value dark warm brown, dark-value Prussian blue, dark warm brown, darkest black-violet, earth green, green-gray, golden brown, light-value blue-gray, mars violet, middle-value blue-gray, middle-value green, middle-value pink, middle-value violet, neutral grays, pink, Prussian blue, umber, very dark-value browns, violet, white

Water: dark burnt umber, light blue-gray, light blue-green, raw umber, white

WATERCOLORS
Underpainting: Alizarin Crimson, Burnt Umber, Cadmium Yellow Medium, Ultramarine Blue, Winsor Green, Yellow Ochre

OTHER
Standard drawing pencil, nos. 6 and 12 watercolor brushes, tape

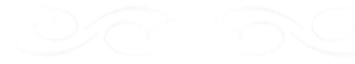

1. Sketch and Underpaint the Leaves and Rocks

Lightly sketch the composition with a standard drawing pencil. Make compositional adjustments and changes as you feel necessary.

Wet the back side of the museum board using your no. 12 brush, then flip it to the front and tape it to your drawing board.

Underpaint the leaves using either Winsor Green or a combination of Alizarin Crimson and Cadmium Yellow Medium. Use light shades of Yellow Ochre and Alizarin Crimson for the dry light-value rocks. Use the smaller brush for small shapes and the larger brush to lay in broader areas of color.

2. Continue Developing the Underpainting

Using your no. 6 brush and a mixture of Ultramarine Blue and Winsor Green, lay in the water areas.

For the darkest underwater rocks and shadows, apply a dark mixture of Burnt Umber and Alizarin Crimson. Lighten this mixture with touches of Yellow Ochre, and add this to the mid-value underwater rocks and shadows. Again, use the smaller brush for small shapes and the larger brush to lay in broader areas of color.

You want to keep the value of the underpainting darker than the final local color. The colors chosen for the underpainting will help the leaves pop when the final color is applied, because these colors contrast with the pastels used in later steps. Additionally, skewing the color of the water in the underpainting toward green will help make the final color warmer, and using warm tones under the dry, nearly white rocks will keep them from ending up too cold and drab.

3. Lay In Dark Values With Pastels

Once the watercolor underpainting is dry, begin laying in the darkest values of violet and browns on the underwater rocks that are in shadow. Do the same with the darkest values of Prussian blues and blue-grays on the underwater rocks that are in sunlight. Use light strokes so you'll be able to add more layers of color later. The blue underwater rocks will be developed through greener tones and have pinks and violets added later—this blue is just a preliminary layer.

4 Develop the Rocks

Continue laying in browns and blues on the underwater rocks, moving into middle values. As you do this, use warmer, lighter midtones to indicate planes closer to the surface of the water and cooler, darker tones to indicate planes deeper underwater.

Begin refining forms, but don't get too detailed yet. Play with middle-value greens, pinks and violets to give life and variety to the blue areas and to define the rocks.

Lighten the value of the blue water at the top of the painting with light blue-grays, light blue-greens and white.

Turning your attention to the dry rocks, use light-value neutral grays and umbers to establish the first statement of your lightest lights. Begin modeling the rocks with slightly darker light values of gray, umber and peach. Begin refining the rock edges with precision, then gently finger-blend the colors.

5 Further Refine the Rocks and Begin the Tree Reflections

Slightly tone down the values of the dry rocks to further refine their forms. Create more differentiation in the brown rocks, first by restating the darkest black-violets between the underwater pebbles, and then by using a very golden brown on the shallowest underwater rocks. Make sure the pastel begins to cover solidly.

Emphasize the side edges of the dry rocks by lightly dragging a dark blue-gray pastel across the dark browns. Create complex color in the deeply shadowed black-violet areas by covering them in a dark earth green color. Using your very dark violet, draw in the bare branches of the tree reflected in the water.

6 Continue Developing the Tree Reflections

Draw in the remainder of tree branches and leaves reflected in the water. Use a darker burnt umber to create a feeling of greater depth in select areas of the water, and use a lighter raw umber on the shallower surfaces.

Apply middle-value umbers and tans for the lightest colored branches. Add middle-value peaches and cream colors for the lightest value leaf reflections, and a light-value ochre and rose for the highlights on the branches near the center.

Add light-value blue-gray highlights and dark-value cool green to the center brown rock.

7 Add Finishing Touches

After refining the reflected tree branches and leaves, and adding a few details to the surfaces of the rocks, begin painting the fallen leaves. Use your reference photo as a guide, but make any changes you see fit. Experiment with a wide variety of colors, including cool greens, warm greens, dark rusts, bright oranges, strong peaches, golds, gold ochres, light yellows and soft whites. Draw the most important leaves with accuracy and leave others as gestural or less distinct marks of color. Apply the color thickly.

Continue painting leaves, bringing colors up to correct lightness and warmth. Using dark burnt umber, gently anchor the leaves with shadows. Add white on the dry rocks and selected leaves to achieve a good value balance and a few highlights. Refine the forms of reflected branches and leaves by reintroducing blue judiciously in spots. Strengthen the peach color in the reflected light on the side surfaces of the dry rocks. Add remaining touches of highlights and strong colors as needed to make the water sparkle.

Waterstone #1 - Colette Odya Smith
Pastel over watercolor on 4-ply Rising museum board - 20" × 20" (51cm × 51cm)

Observing the Ways Light Can Change the Color of Water

If you want to paint the ocean, you have to spend hours observing it. One of my favorite things to study is the way light shines through a breaking wave, changing the color of the water itself. The yellow of the sunlight practically glows in the wall of water just before it crashes, and sometimes the sand picked up by the moving wave is visible at its base. Reflections of a cresting wave may be visible for a few seconds as it breaks, and the patterns of ripples and foam as they move up the shore reflect a complex and beautiful interplay of transparency and luminosity.

Materials

SURFACE
18" × 24" (46cm × 61cm) white Richeson premium pastel surface

PASTELS
Sand: beige, brown, brownish orange, burnt sienna, light brown, lavender, light brown, middle-value blue, middle-value brownish orange, purple-blue, orange, rusty brown, yellow

Sky: gray-blue, light gray, light turquoise, middle-value blue, turquoise, very light gray

Underpainting: beige, blue, blue-gray, blue-green, burnt sienna, dark blue, dark yellow-green, green, lavender, lavender-gray, light blue-gray, middle-value beige, middle-value blue, middle-value blue-gray, middle-value brown, orange, turquoise, very light lavender-gray, yellow-green

Water behind the wave: blue, blue-green, dark blue, dark turquoise, light-value turquoise, middle-value turquoise

Waves: blue, blue-gray, blue-green, brownish orange, brownish yellow-green, dark blue, dark greenish blue, gray, gray-blue, gray-white, light blue, light gray, light gray-white, light middle-value dark greenish-blue, middle-value blue-gray, middle-value brownish orange, middle-value dark blue, middle-value dark blue-gray, middle-value turquoise, turquoise, very light yellow-white, white, yellow-green

PASTEL PENCILS
Sketch: dark blue, dark rusty brown, dark green, middle-value blue, orange

OTHER
½-inch (12mm) synthetic bristle brush (old or well-worn), foam brush, paper towels, Turpenoid

REFERENCE PHOTO
Taking lots of photos with a camera set for recording fast action will provide you with valuable reference material for the studio. The focal point of this picture is the breaking wave, with other points of interest in the foreground waves and foam. Compositional changes will include omitting the background breaking wave and omitting the pier, which is a distraction.

1 Complete the Sketch

Using a hard pastel or pastel pencil in a dark blue or green, draw the major compositional lines onto your surface. Place a grid if necessary, using a different color (such as an orange pastel pencil) to differentiate grid lines from compositional lines. The horizon line where water meets sky must be perfectly horizontal and straight.

2 Lay In the Underpainting

Use the sides of your pastels. Paint the sky a light lavender-gray across the top with a slightly darker blue-gray just above the horizon. Lay in the blue sky with middle-value blue. Block in the water behind the wave with middle-value blue and blue-green, and add dark blue on the left just above the swell. Where the sunlight shines through the wave, lay in a strong yellow-green, with a little darker yellow-green on the base at the left. Using middle-value brown, lay in the sand color at the base of the wave on the left. Add two small bits of darker green at the bottom of the wave in the center and on the right, and the crest of the wave at the right. Moving to the midground, lay in middle-value blue-gray, blue and turquoise. Block in the sand with middle-value beige, lavender and orange. Leave the areas of foam untouched. Paint the light in the breaking wave with a strong yellow-green.

3 Wash With Turpenoid

Dip your clean, old bristle brush in Turpenoid. Touch the brush to a paper towel to remove any excess, then paint each area of color separately. Begin with the lightest colors. Let the surface dry.

Study the composition to see if any areas need improvement. For example, the curve of the second wave on the left has an area of green water where the light shines through. Expand this shape in the middle, adding more pastel of the same color.

4 Paint the Sky and Distant Water

Paint the sky using two or three values of gray and gray-blue. Rub lightly with your fingers to blend, being careful not to dull the color.

Fill in the distant water behind the breaking wave using the same turquoise blue you used for the underpainting, plus a darker and lighter value of the turquoise. Apply the colors with quick, short horizontal strokes. Then lightly drag the side of a very soft dark blue pastel across the painted water. The rough surface will catch little bits of pastel, creating the impression of movement.

Use the same dark blue to lightly indicate the most distant swell of water. With a slightly lighter value of blue-green, indicate the swells between it and the breaking wave. Lightly drag your finger straight across the line where sky and horizon meet to slightly soften the edge.

5 Begin the Crashing Wave

Using a dark greenish blue, define the top edge of the breaking wave. Move to the next lighter value of the same color and block in a wider swath of color along the top. With a lighter greenish blue, gently skim over the area where the light will shine through the water.

Using a middle-value brownish orange, lay in the color of the disturbed sand at the bottom of the wave. Gently tap or blend these colors with a light touch of your finger, moving down from the top of the wave to the base. Also blend horizontally where the color of the sand softens beneath the water.

With a very light gray-white pastel held on its side, block in the masses of splashing foam. Lightly draw in the shape of the area where the wave begins to break, being careful not to paint too many droplets or too much detail at this stage. With a middle-value dark blue, indicate the shadow at the base of the foam where it meets the flat water and the subtle shadows of the masses of foam in the crashing wave. Tap these lightly with your finger to soften and mute the color.

Don't worry about completely finalizing the wave at this point; you'll go back to it again later for finishing touches.

6 Block In Remaining Waves

Look for the rhythm and shape of the remaining waves and block these in. Beginning with the light gray-white pastel held on its side, lay in the shapes of the lightest values of the foaming edges. Use a middle-value blue-gray to define the swells and ripples in the middle section of the painting. With a brownish yellow-green, lightly cover the bright yellow-green color in the light area of the wave breaking on the left. Remember that you must keep it slightly muted in comparison to the main wave so the viewer knows which one is the focal point.

Skim some of the brownish orange sand color into the shallow parts of the incoming waves. Then skim a layer of blue-gray of the same value over this, and tap or stroke lightly to blend.

With your middle-value dark blue-gray, indicate the edges of the foam where it meets the sand. Then with a light-value gray-blue (not your lightest value) indicate the pattern of ripples on the swells in the middle waves.

7 Refine the Middle Section and Finalize the Left Wave

Continuing to work with closely related values of blue-gray, blue-green, and light blue-gray, refine the shapes of the swells between the large breaking wave and the smaller one on the left. Avoid using your lightest gray-white except on the very edges of the foam as it crashes on the shore.

Paint the reflection of the focal-point wave on the water in front of it, using slightly darker values than the color of the foam. Keep your strokes horizontal to indicate flatter water. Paint the swell just in front of the reflection with a middle-value turquoise blue, and then skim the streaks of foam across it using your light gray.

Keeping in mind that the wave breaking on the left must remain less important than the focal-point wave, soften the colors slightly and place a bit of foam moving up the curve of the breaking wave. Begin defining the flat section of water in front of that wave by skimming the shapes of foam with a light-value gray-white across the underpainted sand. Work into the edges of the foam where it meets the sand by increasing the pressure on the pastel stick as you approach the edge. Continue this treatment across to the middle of the shallow waves in the foreground.

Breaking Wave - Maggie Price
Pastel on white Richeson premium pastel surface - 18" × 24" (46cm × 61cm)

8 Add Finishing Touches
Continue working across the shallow ripples of incoming water, then move to the area of foam on the sand. This is a bit tricky because the color of the sand comes through the water, but is a slightly darker value than the dry sand. Hold a middle-value blue pastel on its side and skim across the entire area of wet sand. Repeat with a purple-blue of the same value. Tap to blend into the color underpainted below. If you find you're covering up too much of the underpainting, lift off pastel with a foam brush. Repaint the foam patterns if they blurred too much in the last step.

Paint the dry sand with quick little dots of color, including the original color used in the underpainting, plus a lighter and darker value of a similar color. Also add touches of a slightly lighter yellow and orange, and a slightly darker rusty brown. Tap to soften edges.

Add true white on the rim of the breaking wave and in the crashing foam closest to the curve of the wave. To finish, make final adjustments to highlights and edges.

The End Is Only the Beginning…

Throughout my many years of painting, the more I learn about light and shadow, the more I realize I've yet to learn. Like peeling an onion, each layer of understanding reveals further layers to explore.

With the sheer volume of possibilities to consider, the study of this complex subject might seem overwhelming at first. After all, this book merely scratches the surface of everything you need to know. However, you've certainly acquired a strong foundation for recreating sunlight and shadow in your work, so don't be afraid to put pastel to paper and begin your own journey toward greater understanding of the subject.

Whether you're studying a subject before you begin your painting, or you're stepping back to determine if your painting is finished, keep the following questions in mind to help ensure your success:

- What is my range of values?

- Is the distinction between sunlight values and shadow values clear?

- What is the color and temperature of the light?

- What is the direction or angle of light?

- Are any environmental factors affecting the light?

- Are the shadows crisp-edged and hard or softly diffused and subtle?

- What color are the shadows?

- Is reflected light present in the shadows?

- How do shadows help describe the form upon which they are cast?

- What objects are present in the reflections, and what are the colors and values of these objects?

I hope that you've enjoyed exploring light and shadow with me and that you're excited about continuing your study of these subjects. Remember: The end of this book is only the beginning of your next step on your artistic journey!

Anna and Zoe - Maggie Price
Pastel on white Richeson premium pastel surface - 24" × 18" (61cm × 46cm)

Phil Bates

Phil Bates was told by school counselors that he should avoid pursuing art and take sensible classes like business administration. After struggling with various jobs for ten years, he took up graphic design in 1985 and quickly became a full-time commercial artist. Shortly thereafter, he founded Artbeats, a company that specialized in designing backgrounds for desktop publishing. Since then, Artbeats has evolved to produce stock footage for both broadcast television and feature films.

Bates now divides his time between cinematography and painting, with each discipline complementing the other. As a resident of rural southern Oregon, he often shoots reference photos of local rivers, creeks, meadows and mountains. Bates has studied under Richard McKinley, Albert Handell, Ken Roth and Terry Ludwig.

Bates lives in Myrtle Creek, Oregon, with his wife and three children.

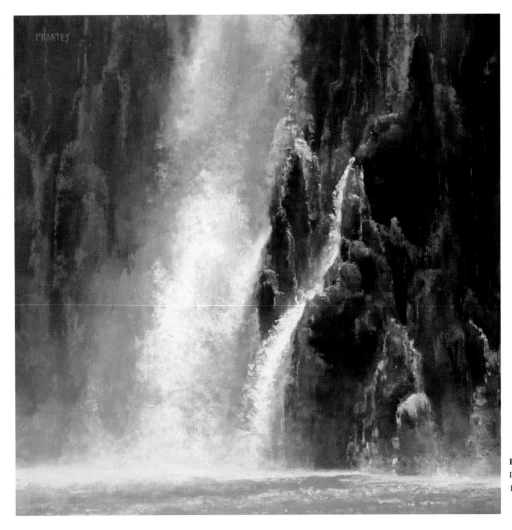

Burney Falls - Phil Bates
Pastel on Wallis sanded pastel paper
18" × 18" (46cm × 46cm)

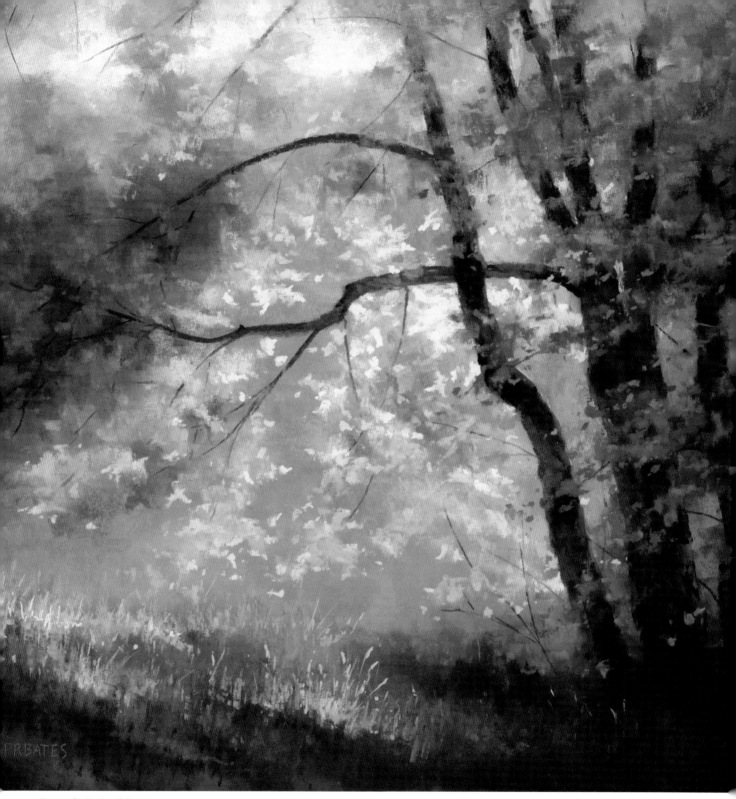

Tree on the Bank - Phil Bates
Pastel on Wallis sanded pastel paper - 18" × 18" (46cm × 46cm)

Liz Haywood-Sullivan

Liz Haywood-Sullivan is a traditional representational artist specializing in pastel landscapes. Her paintings are defined by strong contrasts and color, dramatic lighting, and graphic compositions that often feature the interplay between man and the environment.

After graduating in 1978 from the Rochester Institute of Technology, she worked as an industrial designer, museum exhibit designer, illustrator and architectural renderer. She spent eleven years serving the high-tech industry at Haywood+Sullivan, Inc., a graphic design business she ran with her husband, Michael. In 1996, after taking a pastel class in Taos, New Mexico, she left design for fine art and has worked as a professional pastel artist since.

Haywood-Sullivan is the vice president of the International Association of Pastel Societies and holds Signature memberships in a number of esteemed societies, including the Pastel Society of America. She has twice been awarded the Diane B. Bernhard Gold Medal Award of Excellence, and her work has been exhibited at the Butler Institute of American Art and the Cahoon Museum of American Art. She has been profiled in numerous publications, including *The Pastel Journal, American Artist* magazine and *The Artist's Magazine.*

Her paintings are represented by the Vose Galleries of Boston, and her work can be found in private and corporate collections nationwide. In addition to painting, her schedule includes conducting workshops in pastel painting and art management, both nationally and internationally.

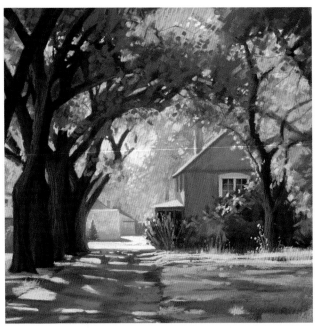

Ranchos Afternoon - Liz Haywood-Sullivan
Pastel on Wallis sanded pastel paper - 16" × 16" (41cm x 41cm)

Commonwealth Avenue - Liz Haywood-Sullivan

Pastel on Wallis sanded pastel paper - 36" × 24" (91cm × 61cm)

Kim Lordier

Kim Lordier combines keen observation, sensitivity and a rich color palette to craft her award-winning landscapes. Inspired by the early California Impressionists, Lordier is fascinated with the unique qualities of California and strives to capture the abstract qualities of light as it plays upon the landscape.

Native to the California Bay Area and a 1989 graduate of the Academy of Art University in San Francisco, Lordier has been involved in the arts most of her life and has been painting full time since 2001.

Lordier, recently featured in national periodicals like *Southwest Art* and *The Pastel Journal*, has garnered top awards from the Carmel Art Festival, Sonoma Plein Air and the Napa Valley Museum. She was one of fifteen artists selected for *American Artist* magazine/Forbes Galleries residency at Forbes Trinchera Ranch in southern Colorado, which culminated in an exhibition at the Forbes Galleries in New York and a feature article in the *American Artist* magazine in 2007.

Lordier is an Artist member of the California Art Club and a Signature member of numerous organizations, including the Pastel Society of America. She is currently represented by Rieser Fine Art in Carmel, California; Sekula's Fine Art and Antiques in Sacramento, California; Debra Huse Gallery in Balboa Island, California; and Knowlton Gallery in Lodi, California.

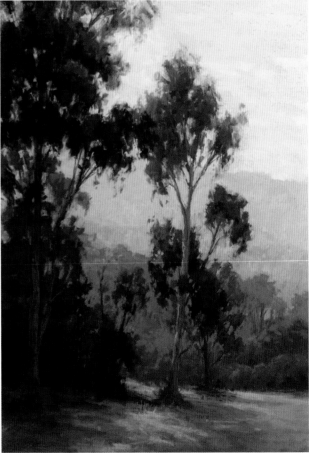

Serenity - Kim Lordier
Pastel on Belgian mist Wallis sanded pastel paper - 36" × 24" (91cm × 61cm)

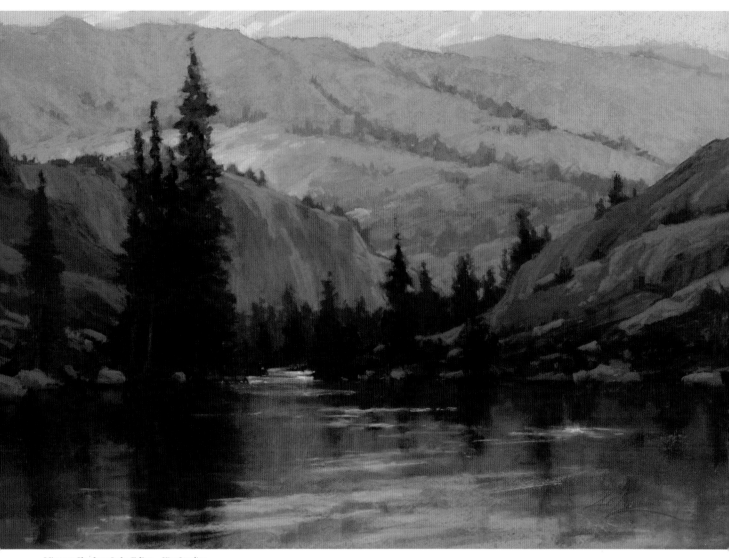

Minaret Shadow, Lake Ediza - Kim Lordier
Pastel on Belgian mist Wallis sanded pastel paper - 24" × 36" (61cm × 91cm)

Richard Lundgren

Richard Lundgren is a Signature member of the Pastel Society of America and belongs to the Master Circle of the International Association of Pastel Societies. He is also a member of the Degas Pastel Society, the Pastel Society of North Florida and the St. Augustine Art Association. He is the director of the Jacksonville Coalition for the Visual Arts.

Lundgren received his degree in Art from Bowling Green State University, studied drawing and design at the Art Institute of Chicago and studied painting at the University of North Florida. He has attended workshops with Doug Dawson, Maggie Price, Sally Strand, Daniel Greene, Albert Handell, Lorenzo Chaves and Christina Debarry.

Lundgren's work has been widely exhibited, won numerous awards and been included in publications such as *The Pastel Journal* and *Pastel Artist International*. He is currently represented by Waterwheel Art Gallery in Fernandina Beach, Florida. He lives in Jacksonville, Florida, with his wife, Nancy.

December Palm - Richard Lundgren
Pastel on Wallis sanded pastel paper - 18" × 24" (46cm × 61cm)

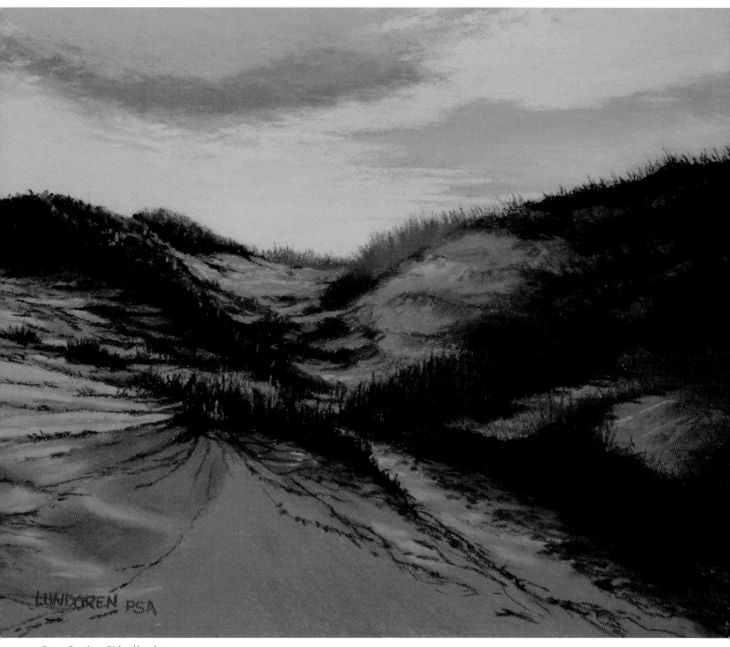

Guana Sunrise - Richard Lundgren
Pastel on sandstone Richeson premium pastel surface - 11" × 14" (28cm × 36cm)

Colette Odya Smith

A Milwaukee native, Colette Odya Smith is a widely exhibited, award-winning pastel painter whose intimate landscapes skirt the edge of realism and abstraction. She has exhibited regionally and nationally for fifteen years, receiving multiple honors from publications, including *The Pastel Journal*, *The Artist's Magazine*, *International Artist* and *American Artist*. She's been featured in stories in both *American Artist* and *The Pastel Journal* and was named one of "75 Women of Influence" in the arts by the *Milwaukee Journal Sentinel* in 2006.

Her work is in many private and corporate collections, including Northwestern Mutual, Waukesha Memorial Hospital, and Deloitte and Touche LLP, and can be found in the permanent collection of the Wichita Center for the Arts.

Smith majored in fine art, humanities and education at Macalester College and studied soft pastels at the Milwaukee Institute of Art and Design. She teaches workshops at the Peninsula School of Art in Door County, Wisconsin. She is represented by the Katie Gingrass Gallery in Milwaukee; Woodwalk Gallery in Egg Harbor, Wisconsin; Richeson School of Art & Gallery in Kimberly, Wisconsin; and Brio Art Gallery in Galena, Illinois.

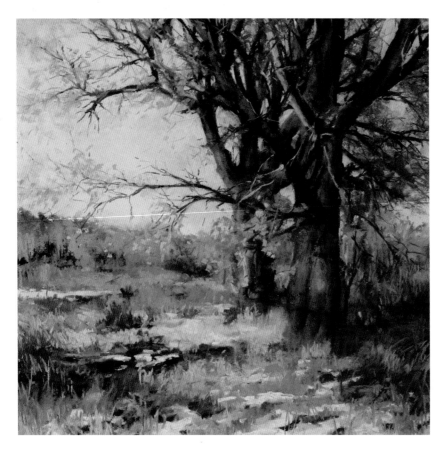

Old Friends - Colette Odya Smith
Pastel on 4-ply Rising museum board
20" × 20" (51cm × 51cm)

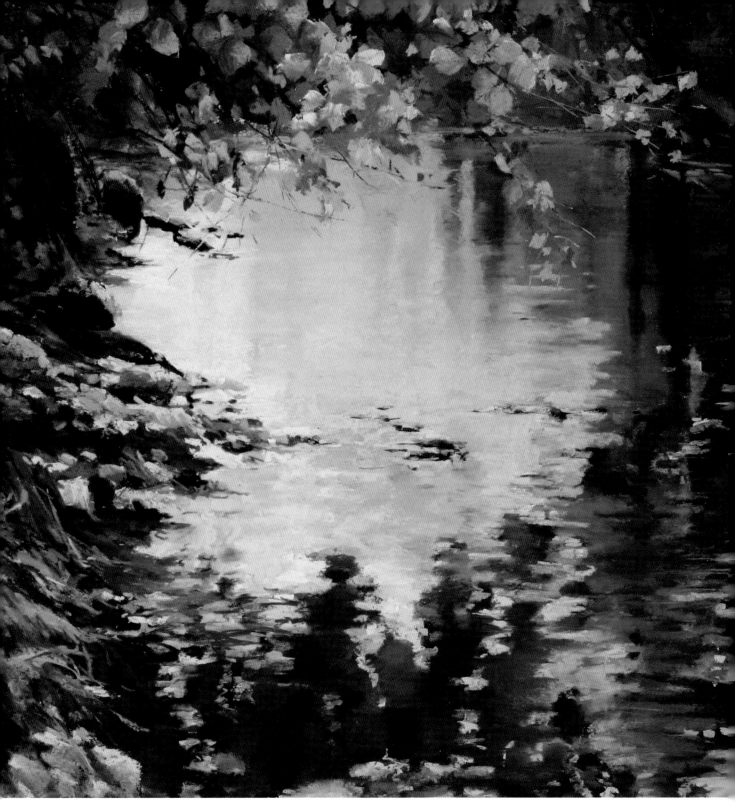

The Embrace - Colette Odya Smith
Pastel on 4-ply Rising museum board - 20" × 20" (51cm × 51cm)

Index

Other fine North Light Books are available from your favorite bookstore, art supply store or online supplier. Visit our website at www.fwmedia.com.

15 14 13 12 11 5 4 3 2 1

DISTRIBUTED IN CANADA BY FRASER DIRECT
100 Armstrong Avenue
Georgetown, ON, Canada L7G 5S4
Tel: (905) 877-4411

DISTRIBUTED IN THE U.K. AND EUROPE BY
F+W Media International
Brunel House, Newton Abbot, Devon, TQ12 4PU, England
Tel: (+44) 1626 323200, Fax: (+44) 1626 323319
Email: postmaster@davidandcharles.co.uk

DISTRIBUTED IN AUSTRALIA BY CAPRICORN LINK
P.O. Box 704, S. Windsor NSW, 2756 Australia
Tel: (02) 4577-3555

Library of Congress Cataloging in Publication Data
Price, Maggie
 Painting sunlight and shadow with pastels : essential techniques for brilliant effects / Maggie Price. -- 1st ed.
 p. cm.
 Includes index.
 ISBN-13: 978-1-4403-0391-3 (pbk. : alk. paper)
 ISBN-10: 1-4403-0391-6 (pbk. : alk. paper)
 1. Pastel drawing--Technique. 2. Sunlight in art. 3. Shades and shadows in art. I. Title.
 NC880.P745 2011
 741.2'35--dc22
 2010032731
Edited by Layne Vanover
Production edited by Maija Zummo
Designed by Guy Kelly
Production coordinated by Mark Griffin

Metric Conversion Chart

To convert	to	multiply by
Inches	Centimeters	2.54
Centimeters	Inches	0.4
Feet	Centimeters	30.5
Centimeters	Feet	0.03
Yards	Meters	0.9
Meters	Yards	1.1

About the Author

Maggie Price is the co-founder, former editor and a current contributor for *The Pastel Journal* and has written more than a hundred articles about pastels and distinguished pastel artists. She serves on the editorial advisory boards of *The Pastel Journal* and *The Artist's Magazine*, and is the author of *Painting with Pastels: Easy Techniques to Master the Medium* (North Light Books, 2007).

Price is a Signature member of the Pastel Society of America, Signature member and Distinguished Pastelist of the Pastel Society of New Mexico, Signature member of the Plein Air Painters of New Mexico, as well as a member of the Master Circle of the International Association of Pastel Societies and the Salmagundi Club of New York City. She is the President and a member of the Board of Directors of the International Association of Pastel Societies.

In addition to her busy painting and writing schedule, Price teaches national and international workshops in pastel each year and frequently juries or judges art exhibitions. More information and images of her work can be found at www.MaggiePriceArt.com.

Acknowledgments

I'd like to thank all the wonderful pastel artists whose work I have enjoyed and admired over the years, which has often provided me with inspiration when I most needed it.

Deepest gratitude to my students, whose questions make me think and, in the process, develop a better understanding of the medium of pastel.

Many thanks to the fine people at North Light Books, especially Jamie Markle, whose support and advice has been invaluable, and my editors, Layne Vanover and Mona Michael.

Dedication

This book is dedicated to my husband, partner, best friend and fellow artist, Bill Canright.

Ideas. Instruction. Inspiration.